THE AUTHENTIC HISTORY OF
CINCINNATI
CHILI

THE AUTHENTIC HISTORY OF
CINCINNATI
CHILI

DANN WOELLERT

AMERICAN PALATE

Published by American Palate
A Division of The History Press
Charleston, SC 29403
www.historypress.net

First published 2013

Manufactured in the United States

ISBN 978.1.60949.992.1

Library of Congress Cataloging-in-Publication Data

Woellert, Dann.
The authentic history of Cincinnati chili / Dann Woellert.
pages cm
Includes bibliographical references.
ISBN 978-1-60949-992-1
1. Chili con carne--History. 2. Restaurants--Ohio--Cincinnati--History. 3. Restaurants-
-Ohio--Cincinnati Region--History. 4. Cincinnati (Ohio)--Social life and customs. 5.
Cincinnati Region (Ohio)--Social life and customs. I. Title.
TX749.W63 2013
641.82'36--dc23
2013012608

To my favorite foodie, Jeanne.

CONTENTS

MEET CHILITOWN, USA

Cincinnati-style chili is as unique as the Ohio River city that gave its name. Some would argue that it's not chili at all. But to the many Cincinnati devotees who've developed the "crave," that's just heresy. Invented by two Slavic-Macedonian immigrants, the brothers Kiradjieff, in a burlesque theater in downtown Cincinnati during prohibition, it has become a more than $100 million industry. The Kiradjieffs created a virtual chili diaspora in the city. How could they have known the legacy they were to create? That legacy in Cincinnati boasts more than 250 chili parlors, more per capita and square mile than in any city in the world. Roughly 225 of those parlors are split between corporate brands Skyline Chili and Gold Star Chili, and the rest are independents or smaller chains. Snowbirds can enjoy Skyline Chili in Fort Lauderdale, Florida, and four other locations in the Sunshine State. It has spread as far as the Middle Eastern nations of Jordan and the United Arab Emirates. Since December 2012, pilgrims can even visit the birthplace of Christ and eat Cincinnati-style chili at the Bethlehem Chili House, founded by the son of Fahid Daoud, one of the founding brothers of Gold Star Chili. Christ and a cheese coney—what a religious experience!

Cincinnati-style chili has achieved a cult status in the region. Wedding photos in Cincinnati have shown brides stuffing cheese coneys into grooms' faces rather than pieces of cake. Two weddings have taken place at the Bellevue Kentucky Gold Star. Owner "Chill" Rick Schmidt provided cake and free meals to the newlyweds. Women have found diamond rings hidden in a bowl of oyster crackers in a chili parlor. And even as unusual as it may

sound, some Cincinnati families have replaced the traditional Thanksgiving turkey dinner with a chili bar, complete with all the fixings. Cincinnati chili has made it into country songs like "Coming to Your City" and blues songs like "Camp Washington Chili."

Cincinnati chili for natives is a taste that's developed from birth. And to out-of-towners, you either love it or hate it. It's been called culinary barbary, faux chili and even weak spaghetti sauce—ouch! It's made news in the *New York Times* and numerous culinary magazines, as well as on a variety of Food Network programs. A particularly bitter female Cincinnati food critic once said that she couldn't understand why people were eating it. Word to the wise: if you want to live comfortably in Cincinnati, don't bash the chili.

The numbers don't lie about chili's popularity in Greater Cincinnati. The Cincinnati Chamber of Commerce estimates that Cincinnatians annually go through 2 million pounds of chili topped by 850,000 pounds of shredded cheddar cheese. The Clifton Skyline once reported that it sold 1,600 York Peppermint Patties at its counter to save the onion breath of its customers. Dixie Chili reported that it went through a combined 1,000 pounds of cheese per week, and the Clifton Skyline reported that it consumes roughly 250 pounds of cheese per week. Good thing we're not a city of lactose intolerant people!

Cincinnati chili is similar to most peasant or comfort foods. Its most popular form, the three-way, is mostly inexpensive starch in the form of spaghetti, with a small layer of meat and a sprinkling of cheese on top. It's both economical and filling. It's a bit like another Cincinnati favorite, goetta, which uses a little bit of pork and a filler of pinhead oats and spices. Goetta was invented by German immigrants in Cincinnati in the mid-nineteenth century. In the same way you won't find a version of Cincinnati chili anywhere in Greece, you won't find a version of goetta anywhere in Germany. What is it about Cincinnati that makes inventing new food categories so appealing?

The other most popular form of Cincinnati-style chili is the cheese coney. The cheese coney has its roots on Coney Island in New York in that it contains chili piled over a hot dog on a bun. But that's where the similarity ends. It's a bit like comparing Cro-Magnon men to modern Homo sapiens—related but different. Comparing Coney Island chili to Cincinnati chili is like comparing goetta to its East Coast cousin, scrapple, which is made with cornmeal in the place of pinhead oatmeal. It's clear that we have something better in Cincinnati on both accounts, and some chili parlors serve both delicacies together.

Cincinnati expats who've developed the crave request frozen chili from relatives and the dry spice blends from their new homes around the world.

A 2010 industry report commissioned by Gold Star Chili estimated that Greater Cincinnatians spend $16 million at the grocery buying frozen and canned products, as well as ingredients, to make their own versions of Cincinnati-style chili. And the Cincinnati chili parlor is on the trifecta of places to visit when they return home (along with LaRosa's and Graeters Ice Cream). I recently posted a comment on Facebook about Cincinnati chili just to see where it would go. A nonnative friend commented in the negative, and you couldn't imagine the flurry of comments from chili lovers rushing to defend their hometown favorite.

As a native myself, I've read countless *Enquirer* and *Cincinnati* magazine articles about Cincinnati chili. But I wanted to get to the bottom of Cincinnati chili mythology. I wanted to call on the chili oracles, be inspired by the chili muses and trace the Cincinnati chili family tree. For me, many questions remained unanswered. Who was the first to invent the formula, and will we ever know the unique spice blend? What's different between each of the chili formulas? How did we come to use cheddar cheese instead of a more Greek cheese like feta? What was happening in Macedonia and Greece that made the scores of Greek- and Slavic-Macedonian immigrants move to Cincinnati during World War I? Did Skyline and Dixie Chili steal the recipe from Empress? Is the blend based on a traditional Greek dish like moussaka or pastichio? Does it really have cinnamon and chocolate in the formula? What's the proper way to eat a three-way—inverted or normal, dry or juicy, cutting or swirling? Does the type of oyster cracker affect the taste of the chili?

Like Greek mythology, it all started with the titans (chili titans to be exact): the brothers Kiradjieff. So that's where I started. Assen, or Joe, Kiradjieff is Cincinnati chili royalty. As the son of Empress founder Tom, he has been in the business longer than any living person in Cincinnati. Some might call him a trash talker. I'd like to think of him as a subject matter expert. In a town with so many competitive chili parlors, how could there not be a bit of competitive chatter—all, of course, with a wink, a smile and a bit of tongue-in-cheek. It wasn't difficult to meet with the other chili owners. They're Macedonian and Greek. They have that Aegean machismo that makes it easy for them to talk about how their chili formula is best. They're all great storytellers—they come from a long line of great storytellers. And they're funny. No interview lacked lots of laughter.

The Cincinnati chili pioneers came from northeastern Greece in a highly contested area known as Macedonia. The area was located near the borders of Albania, Yugoslavia, Bulgaria and Turkey. It's maybe a bit like the tri-state area—the intersection of Kentucky, Indiana and Ohio. But there was

certainly more cultural strife at their geographic intersection. They were predominantly Slavic Macedonians and were unfortunately in the wrong place at the wrong time. The Ottoman empire was crumbling, and the newly independent states of Greece, Serbia and Bulgaria were all vying for control of Macedonia. Many of these chili pioneers came from the mountainous villages around the cities of Kastoria and Argos-Orestikon, the area where Alexander the Great was born and lived. And just like Alexander conquered the peoples of Asia Minor, these immigrants came and conquered a town with a mostly German patina and made it their own.

The first Macedonian American immigrants came from the border regions in the north of what is today Greek Macedonia, primarily the regions near Kastoria, Florina and the southwest of the Republic of Macedonia, notably around Bitola. In the first half of the twentieth century, they were identified as Bulgarians, but that ethnic designation is not really correct. Macedonians speak a language that, while similar to Bulgarian and is Slavic, is truly its own. Macedonian cultural pride spawned an American network of immigrant Macedonian Patriotic Organizations (MPOs), all aimed at freeing Macedonia.

It is estimated that about fifty thousand Macedonians immigrated to the United States between 1903 and 1906, but the outbreak of the Balkan Wars and World War I stopped the flow. About twenty thousand remained in the United States, and the rest returned home. The immigrants were predominately peasants, with the remainder including craftsmen, workers and intellectuals. Immigration restarted after the wars; most of the new immigrants were ethnic Macedonians from Greece, many of whom had been expelled from Greek Macedonia in the 1920s. Another fifty to sixty thousand Macedonians had immigrated to the United States by the end of World War II.

In the 1920 census, there were more than seventy-five male immigrants from Greece and Macedonia living on Fifth Street in downtown Cincinnati. They were all of soldiering age, between fifteen and twenty-one, and were refugees of the Balkan Wars and World War I. The chili parlor became a mode of chain migration, helping other Greek- and Slavic-Macedonian immigrants become acclimated to their new homeland and even set them up with a successful business model that they could use to start their own parlors. Skyline, Empress, Gold Star and Dixie Chili all employed these Greek- and Slavic-Macedonian immigrants.

The Holy Trinity–St. Nicholas Greek Orthodox Church still manages the spiritual health of most of these Cincinnati immigrant families. The church

today is in the Cincinnati suburb called Finneytown. Many Cincinnatians look forward to their yearly Panegyri Festival to taste homemade Greek dishes like pastichio, moussaka and the delicious pastries like baklava, as well as my favorite, pasta flora. Of course, there is also Cincinnati-style chili there. To foodies in Cincinnati, the Panegyri is the best ethnic food festival in the city. In Greek, "panegyri" means a gathering of people all around. Good food is part of this gathering of people. In the Greek community, if your family has someone with a saint's name, you assume that your entire circle of family and friends will be at your door, and there had better be food waiting on that saint's feast day. If you named your son Christos, lucky you—you'll be the ones to have Christmas celebration every year until a new Christos is born in the family.

This parish has its roots in the first Greek Orthodox church, Sancta Trias or Holy Trinity, founded in 1907 on Third Street in downtown Cincinnati. That parish catered to the first wave of Greek- and Slavic-Macedonian immigrants that came to the United States between 1880 and 1900, as well as the second wave that came during World War I. Cincinnati was, at the time, considered the sixth-largest city in the United States and had a large, growing industrial center. A second parish, St. Nicholas, was formed in 1938 to service the continually growing Greek immigrant community in the city. Eventually, the two parishes combined in 1945, and in 1972, they moved out of downtown to the current location in the suburb of Finneytown.

Belonging to the Greek Orthodox church in Cincinnati kept the Greek immigrant group very tight-knit and perhaps made the swapping or "borrowing" of chili recipes even easier. Children went to Greek school together, and their parents spoke every Sunday after mass.

Western Hills High School on Glenway Avenue could be called "Chili High." Many of the early Cincinnati chili pioneers sent their sons and daughters there. The Lambrinides brothers—Bill, Chris and John—of Skyline charmed the halls in the late 1940s. Joe Kiradjieff of Empress smooth-talked his way to a diploma there in 1948, with his sister, Annette, graduating a few years later. Constance Andon, daughter of Steve Andon, founder of Camp Washington Chili, said goodbye to Chili High in 1949. Steve Andon's nephew, Johnny Johnson, and niece, Thelma Johnson Stephan, graduated in the 1950s, and Joe Kiradjieff's second wife, Carol Weiss, graduated in the class of 1958, which was recently added to the school's sports hall of fame.

Section 127 in Spring Grove Cemetery could be called the Cincinnati chili section. It is the final resting place for many of the original chili pioneers, the

brothers Kiradjieff (Empress), the Lambrinides family (Skyline), the Manoff family (Strand, Tip Top and Hamburger Heaven), the Chalkedas family (ABC Chili) and many more. This attests to the tightness of the Greek and Macedonian immigrant community in Cincinnati and northern Kentucky. With a nod to their sense of humor—to those who've gone to that "great chili parlor in the sky"—I say bun voyage, arrivader-chili and auf weiner-sehen. Have a four-way onion waiting for me at the golden counter when I arrive. It is to the many chili pioneers that Cincinnati chili lovers owe a debt of gratitude for their drive, perseverance and ingenuity.

Cincinnati chili restaurants are called chili parlors, and the setting is something uniquely Cincinnati. The very first chili parlor, Empress, had only five tables, and it was called a chili parlor to let customers know that it was not a full-service restaurant. They wouldn't find white tablecloths and tuxedoed servers. But that restaurant was expanded, as many were over the years. Today, some chili parlors can seat several hundred people, even though they still have that small, wholesome family feel. Because the first chili parlors started during prohibition, the vast majority of them do not serve alcohol today.

The Cincinnati chili parlor is much like a 1950s diner or sock hop, a place you might see the Fonz or Joannie from *Happy Days*. Jukeboxes, swivel stools, booths and bright neon signs and clocks adorn the walls. Burger franchises today like Johnny Rockets try to re-create this vintage ambience. It's done unintentionally in Cincinnati chili parlors. They harken back to a simpler time when families sat down every night to eat dinner together.

The parlor is a place to hang out after a movie or a sporting event. Stepping into a chili parlor is like walking into a church picnic or a high school reunion. Some local parlors even have miniature jukeboxes at each booth. For natives, many memories have been made at Cincinnati chili parlors. As a boy, I looked forward to reading the comic wrapped inside a Bazooka bubble gum wrapper after a three-way with the family at the Colerain Avenue Skyline, owned by Mr. Simon. I'll never forget how good late-night chili cheese fries tasted at Mr. Vidas's Chili Time in St. Bernard after a high school football game, nor will I forget being heckled by Squeakie, the second-shift waitress at the Georgeton's Skyline Chili on Ludlow Avenue.

Another commonality of all parlors is an open kitchen, with a grill and steam table surrounded by a counter with swivel stools. In some ways, chili parlors are like diners. Waitresses typically yell the order to the steam table cooks, who portion chili on coneys and on spaghetti with a swift turn of the wrist. The terms "three-way" and "four-way" were invented as shorthand for the waitresses. A chili spaghetti with onions and cheddar cheese is a

"four-way." Each restaurant has its own unique lingo that the waitress yells to the counter. Squeakie, a feisty nightshift waitress at the Ludlow Avenue Skyline in the 1990s used to call waters "Ohio River cocktails"—in that case for humor, not shorthand. Most chili parlor gals greet you as a "Sweetie" or a "Honey" and could talk for hours. Why there's not a song written about the Cincinnati chili parlor waitress is beyond me.

Cincinnati chili is seen in five distinct settings. One can find it in chili parlors that serve only chili, restaurants that don't specialize in chili but serve their own recipe, public venues like King's Island Amusement Park or the stadiums, local groceries and, finally, in Cincinnati homes. Many families have their own recipes that they guard like holy relics. Although the chains of Gold Star and Skyline dominate the number of chili parlors, there are still several solo independent chili parlors that have their own loyal followings. Price Hill, Camp Washington, Pleasant Ridge and Gourmet Chili all have loyal fanbases. Lesser-known independents like Mike's Chili, with two locations in Hamilton; JK's Chili in Deer Park; Moon Lite Chili in Batavia; Cretan Chili in Carthage; and Mr. Gene's Doghouse in Cumminsville also have loyal neighborhood followings.

Cincinnati-style chili has become so ubiquitous that any neighborhood family restaurant that opens is assumed to have a version of this on its menu, even if it's not the main item. Places like Santorini Family Restaurant, owned by the Dinez family on Harrison Avenue in Cheviot, serve chili along with other Greek dishes like gyros. The Mason Grill, opened in 2004 by two boyhood friends from Greece, Kostas Fratzis and Bill Liaros, serve stick-to-your ribs breakfast items along with double-deckers, gyros and Cincinnati-style chili. Angelo's in Finneytown has similar menu items but still finds time to cook its own Cincinnati-style chili. There is even one stall in Findlay Market in Over-the-Rhine, Areti's, owned by Areti and George Papastergiou of Variko, Greece, that serves its own recipe of chili in addition to gyros and wonderful Greek pastries like my favorite, galaktoboureko.

The food truck craze has not been lost on Cincinnati-style chili, either. Mr. Gene's Doghouse in South Cumminsville has a mobile "Weenies on Wheels" that serves its Cincinnati-style cheese coneys. Gold Star Chili has also introduced its Chilimobile, used to serve chili around the city at charity and cultural events.

When it comes to regional etiquette, there's definitely a correct way to eat a three-way, which along with the cheese coney is the most popular item ordered at all chili parlors. It's served on its own type of dish: a football-shaped Cincinnati chili bowl. You will be scolded if you swirl the spaghetti

like a plate of Bolognese pasta—unless you're Italian, and then you can be excused because it's in your blood. You cut it whether you dress it with beans, onions or, as Dixie Chili does, chopped garlic as a six-way. The intent is to taste every layer separately rather than mixed together. One tastes the tangy but cooling cheese, the savory and sometimes spicy chili layer and, finally, the palate-cleansing spaghetti layer.

Most parlors put the dressings on top of the chili before the cheese, but some people like to see the onions or garlic on top. There is some room for personal taste in Cincinnati-style chili. Some people like the cheese on top to be melted, while others like the shredded cheese to be fresh. One can even order an inverted three-way with the cheese on the bottom, just to make sure it reaches a melted, gooey consistency for optimal eating. Some chili parlors like Skyline can serve a juicier version of the chili as well as a drier version, where it is ladled through a slotted spoon to drain off excess juice.

Cincinnati's chili is served on its own type of dish: a football-shaped Cincinnati chili bowl. The football-shaped serving dish was used at the first Empress, but no one of the second-generation Kiradjieff family can recall how his or her father found the dish or when it came about. Don't ever serve it in a round soup bowl if you want to be accepted in Cincinnati.

Each Cincinnati chili parlor seems to have its own variation on the standard cheese coney and three-way chili. The Chili Company invented the slaw dog and the slaw way, Skyline uses a mix of habanero and cheddar cheeses and offered a Skyway, with 50 percent more cheese on top than the normal three-way. Please pass the Lactaid. Gold Star and Dixie Chili offer very different vegetarian versions of their chilis, and Skyline offers a red beans and rice vegetarian option for vegans and abstaining Catholics during Lent. Dixie Chili in Kentucky offers the Gator, a cheese coney with a dill pickle spear nestled in the bun next to the hot dog. If you like brine and salt, this is a dish for you.

The variations in ingredients are unique across the various chili parlors. For its five-ways, Dixie Chili uses pinto beans. At Skyline, you can get kidney beans on your five-way. Gourmet Chili in Newport, Kentucky, serves red beans—stewed separately from the chili—on a five-way. Dixie Chili uses lean ground Kentucky-bred prime beef, while its neighbor, Gourmet Chili, uses bull meat. Founder Steve Stavropoulos said that it made his chili less runny. Most parlors use aged Wisconsin cheddar cheese. Skyline even has a special cheese that it distributes exclusively for Land-o-Lakes.

To me, it's the small things about a particular parlor that make it stand out. For example, I think you can judge a good chili parlor by the type of oyster cracker it serves with its chili. Cincinnati chili oyster crackers are meant

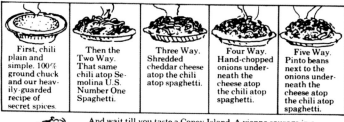

How do people love chili?
Let's count the ways.

First, chili plain and simple. 100% ground chuck and our heavily-guarded recipe of secret spices.	Then the Two Way. That same chili atop Semolina U.S. Number One Spaghetti.	Three Way. Shredded cheddar cheese atop the chili atop spaghetti.	Four Way. Hand-chopped onions underneath the cheese atop the chili atop spaghetti.	Five Way. Pinto beans next to the onions underneath the cheese atop the chili atop spaghetti.

And wait till you taste a Coney Island. A vienna sausage in a steamed bun paddled with mustard and covered with our spicy chili, hand-chopped onions and, for those who insist on everything in life, shredded cheddar cheese. Ain't love grand?

U.S.D.A.
EST. 9061

DIXIE CHILI

CHILI
HOT
CANNED
FROZEN

Famous since '29

Newport - 733 Monmouth Street - 291-5337 Covington - 2421 Madison - 431-7444

Erlanger - 3702 Dixie Highway - 727-2828

VESPER

© Dixie Chili, Inc., 1972

This advertisement from Dixie Chili explains to the chili outsider the various ways to eat Cincinnati chili. Since this ad, Dixie has added a six-way, which adds fresh chopped garlic to a traditional five-way. *Courtesy of Spiro Sarakatsannis.*

to be salty, crunchy, light and big enough to fill a teaspoon. The starchy, thick, tiny New England oyster crackers were meant for clam chowder and tomato soup—not for Cincinnati chili. Dixie and Gourmet Chili serve this second type. One even has a lighthouse image to represent the East Coast. There are no lighthouses in the Cincinnati skyline. My favorites are the buttery, crispy Keebler's oyster crackers that Blue Ash Chili serves. A close second is the always crispy, light and salty crackers served by Skyline. These are the kind that you can puncture a small hole in and fill with a drop of tobacco sauce like a miniature jelly donut, called a shooter. Pleasant Ridge Chili's oyster crackers are crispy but small. They always leave you wanting more. The Shur-Good Biscuit Company in the Cincinnati neighborhood of Oakley makes the unique oyster crackers that should be served with local Cincinnati chili, and several parlors do. Shur-Good is also famous for its ties to another Cincinnati pop-culture food, Mama's Cookies. This legacy brand was introduced and advertised on the *Uncle Al Show* from 1950 to 1985. I'm still bitter that I was the only one of my siblings to not go to the *Uncle Al Show*.

Before the boom of the fast-food market, small restaurants chose well-known locations. For chili parlors, the most advantageous location was near a

neighborhood movie theater. The original Empress was in a small storefront in the "Empress Burlesk," and it later moved to another popular place on Fifth Street—across from the Greyhound bus terminal. Park Chili in Northside was across from the park theater, Liberty Chili was actually in the old Liberty Theatre, Covedale Chili was near Covedale Theatre and 20th Century Theatre in Oakley had a 20th Century chili parlor. Covington Chili, across the river in Kentucky, was across from the Madison Theatre. Dixie Chili was near the Hippodrome and State Theatres in Newport, Kentucky, and its competition, Crystal Chili, was near the Strand Theatre. Even Pleasant Ridge Chili, one of the newest chili parlors in 1964, was next to the Ridge Theatre.

National celebrities and politicians have their favorite Cincinnati chili parlors. Talk show host Jerry Springer lived in Price Hill when he was mayor of Cincinnati and patronized the original Skyline. To celebrate the publication of her first book in a *Sex and the City* episode, Sarah Jessica Parker's character, Carrie, shared a hot dog with her female cabbie, but it is Skyline Chili where Parker chooses to eat her cheese coneys when she visits her hometown. Ludlow Skyline owner said that she eats a large three-way every time she visits. The Bare Naked Ladies band from Canada like Cincinnati chili and even wrote a short song about it for concerts in Cincinnati. For this fan interest, they got a tour of the Skyline commissary, free dinner, backstage catering and deliveries to their hotel. For years, Bob Hope had frozen Skyline Chili shipped to his home in Palm Springs. A younger Bob Hope and Red Skelton frequented Dixie Chili in Newport after comedy shows at the Strand Theatre on Monmouth Street. Singer-songwriter Jimmy Buffet has patronized Camp Washington Chili while on one of his Margaritaville Tours. Larry Flynt wheels his golden wheelchair into the Newport Dixie when he visits town. President Obama stopped in the downtown Skyline Chili on the 2012 presidential campaign trail. Local pizza king Buddy LaRosa frequents Dixie Chili with his son to sample his favorite Cincinnati-style chili.

Just in January 2013, on Anderson Cooper's new show, *Anderson Live*, Cincinnati native Carmen Elektra introduced Anderson Cooper, who claimed he's never had a three-way, to Cincinnati-style Skyline Chili. He commented when she presented him a three-way, "This is clearly not going to help anyone with their New Year's resolution!" After tasting, Anderson said, "Wow, that's a lot of cheese. It's kinda spicy too." Well, he'll need more practice eating three-ways—no one told him to cut it. He also swirled it with his spoon and fork.

And just like Ms. Elektra, Cincinnati expats have taken their love for the chili with them as they move out of the city. In 2009, Edwards, a New

York restaurant in Tribeca, owned by Cincinnati native Edward Youkilis, hosted a monthly Cincinnati Night that featured Skyline Chili. Cinners, a Chicago chili parlor, makes its own version of Cincinnati chili thanks to its owner, Queen City native Tony Plum. Others that serve Cincinnati-style chili outside the state include Chili Mac's in Chicago; Cincy's Downtown in Greensboro, South Carolina; Porchettas in Pensacola, Florida; and Café Blue American Grill in Gunbarrell, Colorado. Although closed now, Manoff's Rancho Burger in Santa Cruz, California, served Cincinnati chili for more than forty years.

For this journey to the Balkans and back, I'd like to thank the following Cincinnati chili royalty for their laughs and stories: Joe, John and Eddie Kiradjieff, sons of the Empress Chili founders; Fahid, Samir and Sami Daoud of Gold Star; Spiro Sarakatsannis of Dixie Chili; Johnny Johnson of Camp Washington and his lovely daughter, Maria Johnson Papakirk; Sam Beltsos and his son, Steve, of Price Hill Chili; Billy Lambrinides, grandson of Nicholas Lambrinides, of Skyline Chili; Art Bowman, former North College Hill Skyline owner; Phillip Bazoff of Park Chili in Northside; Thomas, Katherine, Todd and Joanna Manoff of Strand Chili, Hamburger Heaven and Gold Star Chili recipe legacy; George Stavropoulos of Gourmet Chili; and Gus Perdikakis (and family), son of the owner of Liberty Chili Parlor in Northside. I would like to thank my chili-tasting associate Todd McFarland for his openness to try some of the most obscure chili parlors in Greater Cincinnati. For their help in tirelessly managing local historical photo collections and artifacts, I would also like to thank Cierra Earl of the Kenton County Public Library, Linda Bailey of the Cincinnati Historical Society and the incomparable Valda Moore of the Price Hill Historical Society.

From that chilly day in October 1922, when the first Empress started it all, there has been a steady stream of new chili parlors in Cincinnati and its neighboring northern Kentucky towns. If you do the genealogy, most owners worked at Empress Chili or another legacy chili parlor. All chili roads in Cincinnati lead back to Empress. There have also been many chili parlors that have come and gone over the last ninety years since the dish's invention. But all have made their contribution to the "four Cs"—the collective Cincinnati chili consciousness. Cincinnati-style chili is so ubiquitous now that restaurants that don't define themselves as chili parlors still serve their own recipes of Cincinnati chili. So let's step back in time to the Roaring Twenties and the founding of Cincinnati-style chili.

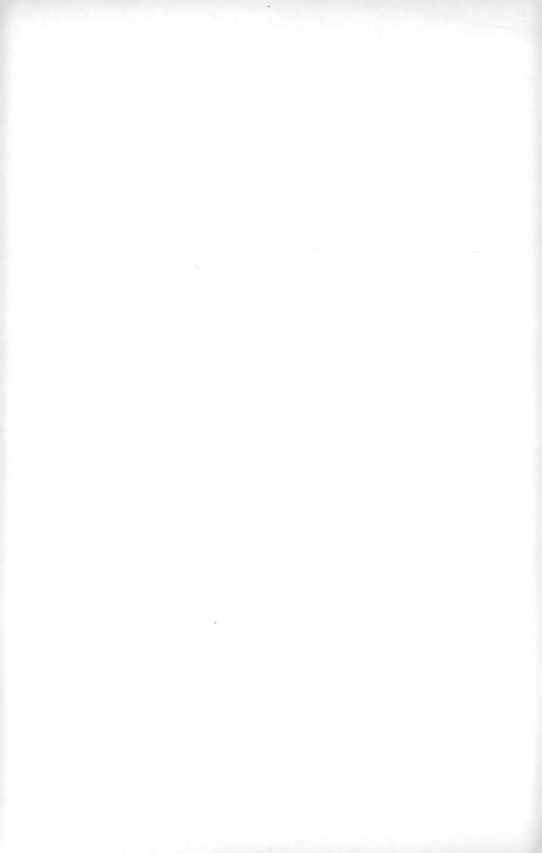

"BURLESK" AND A BOWL OF CHILI

THE HISTORY OF EMPRESS CHILI PARLOR

The legend of Cincinnati chili begins in Hroupista, Macedonia, an area that is now part of northern Greece and known today as Argos-Orestikon. Located in the northwestern corner of the country, just over the Balkan Mountains from Albania, it is the area from which Alexander the Great, king of Macedon, hailed. It is also near the town of Kastoria, where many other Cincinnati chili pioneers, like the Lambrinides family of Skyline, originated.

It was in this area at the turn of the nineteenth century that Slavic-Macedonians Konstantinos Kiradjieff and his wife, Kyratso Pappa, were raising two girls, Maria and Hariklia, and four boys of soldiering age—Argiro, or "Argie"; Athanas, or "Tom" (1892–1960) ; Ivan, or "John" (1894–1953) ; and Ilias, or "Elias" (1892–1982)—at a time of great crisis in Macedonia. This time of crisis led up to a very violent period during World War I and the Balkan Wars that followed.

The name Kiradjieff is a Slavic Macedonian word that roughly translates into "mobile businessman," or someone who transports merchandise from one place to another. Back in the early 1900s, these mobile businessmen used huckster-like wagons pulled by donkeys to traverse from eastern to western Greece. The Kiradjieffs had changed, taking on this new name and leaving their former name, Vasileiou, for this occupation. Konstantinos opened a hardware store in their village as an anchor for their traveling business. Even though they took on the name of their profession, mail was addressed at the hardware store to Vasileiou up until the 1940s. After the area was annexed

to Greece, the family who stayed back changed their name to Kyratsis, so as not to stand out as Slavic.

John Kiradjieff had served some time during his late teens with the Bulgarian army while back home. The Ottoman Turks still held control over the area of Macedonia where they lived. But the newly independent states of Greece, Serbia and Bulgaria—all bordering this region of Macedonia—were wreaking havoc on the Slavic Macedonians of that region. In an effort to win the Macedonians to their respective cause, the surrounding states each started their own propaganda campaigns. The problem was that choosing your alliance could be dangerous depending on who was invading or controlling your village at any one time during this Balkan crisis. It was indeed a tragic time for many in this area, but immigration to America gave them the hope for a new start.

The first Kiradjieff brother to leave for America was Argiro/Argie. Born in Hroupista in 1880, Argie had set himself up in Cincinnati by 1918 as the proprietor of a grocery store at 842 West Fifth Street in the heart of downtown Cincinnati with a partner, Apostolos Vaceloff, who owned the builiding. In 1920, in the few blocks around Argie Kiradjieff's grocery, there were more than seventy-five male Macedonian immigrants between the ages of twelve and twenty-eight who had immigrated because of the turmoil in Macedonia leading up to World War I. Their places of employment were listed as the railroad, the paper mill, the soap factory, tailor shops or restaurants.

Argie was indeed the anchor who brought the Kiradjieff brothers to Cincinnati, but it was they who found their niche and became successful. We can truly thank this little-known Kiradjieff brother for the founding of Cincinnati chili. Without him, there would be no Cincinnati-style chili. Argie paved the way for his two younger brothers to come and set themselves up in business. Appropriately enough, the name Argiro means "of the silver" or "of value" in Greek, and he was certainly of value in setting up his two younger brothers in Cincinnati.

So, brothers Thomas/Athanas and John/Ivan Kiradjieff immigrated together, following their big brother Argie to Cincinnati in the early 1920s. Tom Kiradjieff had taken work as an accountant in Sofia, the capital city of Bulgaria, after being furloughed from the Royal Bulgarian Army in 1917. Restless at his desk job, he soon left Bulgaria for America, taking his younger brother John with him. A portrait of the three Kiradjieff brothers dates them in Cincinnati together in May 1921. The two younger brothers ended up doing a very common thing among Greek and Macedonian

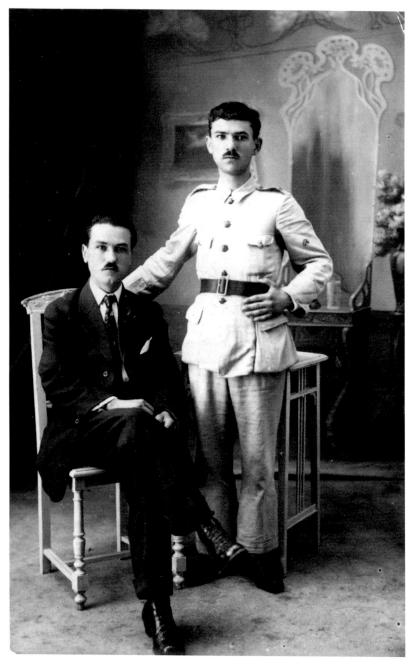

This photo shows John Kiradjieff sitting with possibly his younger brother, Ilias Kiradjieff. Both served for a time in the Bulgarian army. *Courtesy of John Kiradjieff.*

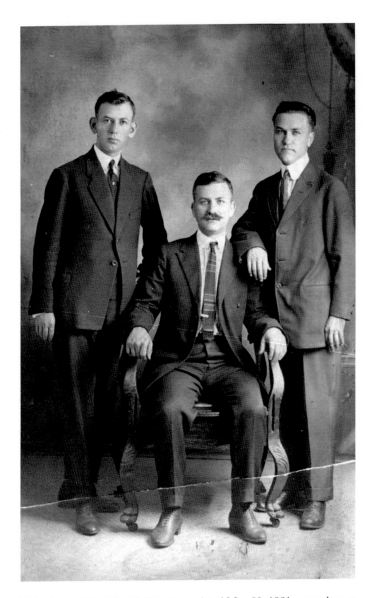

This photo of the Kiradjieff brothers dated May 29, 1921, was taken at Maly's Studio on 635 Vine Street in Cincinnati. *From left to right*: Tom, Argiro and John Kiradjieff. *Courtesy of John Kiradjieff.*

immigrants: they went into the food business. But what they ended up doing was very uncommon among restaurateurs: they created an entirely new food category. In Greek, Athanas means "immortal," and truly what Thomas Athanas Kiradjieff and his brother John created has made them immortal in the minds of Cincinnati chili lovers.

On October 24, 1922, after less than a year in Cincinnati, brothers Tom and John Kiradjieff opened their first restaurant in bustling downtown Cincinnati, on Vine Street between Eighth and Ninth Streets. They named it Empress Chili Parlor, and those who worked there would refer to it for generations as "the Empress." Renting the small corner storefront in the larger Empress Burlesk theater building, the Kiradjieffs thought that the name solidified its location. They called it a parlor to make known that it was not a full-service restaurant. The space only had five small marble tables and a counter with stools. If you stepped back in time to this first Cincinnati chili parlor, you would not recognize the menu as we know it today. The first menu was limited to coneys, without cheese, for five cents, as well as chili spaghetti, also without cheese.

The brothers banked with the newly formed Fifth Third Bank in downtown Cincinnati. Tom initially worked as an accountant at Fifth Third Bank when they settled in Cincinnati. His work in Sofia, Bulgaria, before his emigration had given him the tools for a nice start and the good business sense that would be handy with their chili parlor. Not only did Tom use his accounting knowledge to help build their chili empire, he also used it to bring fellow Macedonians over and get them started in the New World. Many would find work at the chili parlor and then set up their own restaurants or similar chili parlors.

In addition to chili, the first Empress location had a huge caraffe from which coffee was served, and it also operated sort of a dry goods grocery. The brothers wisely stocked a variety of local Ibold cigars in a large corner humidor behind the counter.

The Empress's location was superb. The trend of locating near a theater would be adopted by chili parlors in Greater Cincinnati for the next ninety years. The Empress Burlesk theater opened in 1915 with vaudeville and burlesque attractions provided by the Sullivan Considine national show circuit. After these national circuits, or wheels, closed in the 1920s, theaters like the Empress offered something vaudeville, radio and motion pictures lacked: the striptease act. Uniformed police officers were required by law to patrol theaters like the Empress to censor any sign of indecency. Nowhere else could men see shows as risque as this in public. Scandal broke out at the

This photo shows the "Empress Burlesk" theater in the 1920s, with the Empress Chili parlor to the right. The sign's spelling would later be corrected to Empress Burlesque with a cloth sign. *Courtesy of Joe Kiradjieff.*

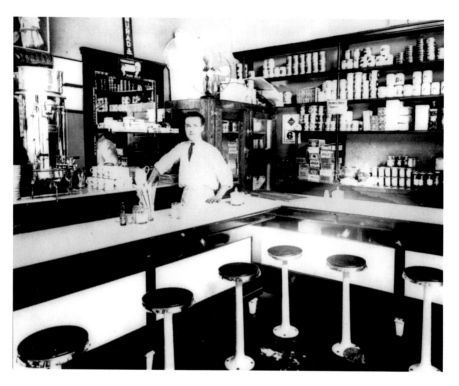

A proud John Kiradjieff poses inside the first location of Empress Chili Parlor in the mid-1920s. The brothers operated a dry goods store in addition to serving chili and sold Ibold cigars from a large humidor behind John in this photo. *Courtesy of John Kiradjieff.*

Empress in 1934 when twelve underage girls were arrested for dancing in the chorus. Ordered to perform strip numbers on stage, one had been beaten by the wardrobe mistress for her refusal.

The Kiradjieffs served something very American—hot dogs, with chili on top, already known as the Coney Island. But more importantly, they served an Americanized version of a Greek stew they called chili spaghetti. It was something totally new for the American palate. In a largely Germanic Cincinnati population, the Kiradjieffs were taking a bit of a risk. The Germanic palate considered paprika "scharf," or spicy. So, the savory and spicy layers that Mediterraneans were familiar with would have been totally foreign to the Germanic population of Cincinnati. The Germanic spice palate didn't have the same diversity as that of the Mediterranean.

The Kiradjieffs took a stew with traditional Mediterranean spices like cloves, cinnamon and nutmeg and added chili powder, along with other

spices familiar to their Slavic Mediterranean upbringing, and called it chili, something easily recognized by Americans. What they didn't know back then was that this creation would spawn hundreds of individual chili parlors between Cincinnati and the northern cities of Kentucky across the Ohio River. Good thing they didn't call it "Americanized Greek stew." This lesson of marketing is worthy of study in MBA textbooks.

The Mediterranean stew that inspired Cincinnati-style chili was probably a lamb stew, not beef. Lamb was more readily available in the hilly Macedonian countryside. Many food writers have tried to attribute ancestry of Cincinnati chili to Greek dishes like pastichio and moussaka. Pastichio is a stew that, like today's Cincinnati-style three-way, has meat on top of a starch (in this case bucatini or tubular pasta) and is covered with cheese (in this case either a custard or a creamy béchamel sauce). Moussaka is a similar dish, only using a vegetarian stew usually made from eggplant. But the cheese came much later to Cincinnati chili, and the only spices that it shares with pastichio are cloves, cinnamon and nutmeg. Joe Kiradjieff, son of Tom, threw his hands up and said, "I don't know," when asked what specific stew was the inspiration for his father and uncle's chili. In a nutshell, it was probably not the particular stew on which Cincinnati chili was based. Tom and John took a dish that Americans would be familiar with, used their Macedonian spices and continued to modify it to customers' wishes. Success came from listening to their customers and modifying as needed.

According to Joe Kiradjieff, chili spaghetti at Empress was originally served like a Bolognese—chili and spaghetti mixed together. Joe said that it was an overly compulsive customer who suggested to Mr. Kiradjieff that it would look much neater if they cooked the chili and spaghetti separately and ladled the chili over top the pasta. It may well have been this customer who also invented the cut-not-twirl method of eating Cincinnati chili. At this time, coneys and the chili spaghetti were naked. They were not sprinkled with the cheese we know today.

Nick Sarakatsannis, a contemporary of Tom and John Kiradjieff, said about Empress in the early days:

Everybody in the old days in the regular restaurants, they had roast beef, roast pork, roast lamb; they didn't sell it today. So the next day they scrape up all that meat, they grind it and they make it chili. They put beans in it, and they call it chili con carne. But in 1922, the Empress, they buy freshly ground beef and they cook it. No roast pork or roast beef leftovers. They use pure beef, no beans. The idea was to have plain meat chili to prove it

wasn't leftovers. And they add the spaghetti. From then on, we all copied. I had my own chili, but I copied the spaghetti.

It was yet another customer at the original Vine Street Empress location who asked for grated cheddar cheese to put on top of the chili spaghetti. Originally, it was served on the side, but when more customers asked for cheese, the Kiradjieffs decided to serve it on top as a standard item. Like the Cro-Magnon man who learned to walk upright, so, too, did this Macedonian concoction evolve into an even more delicious dish.

Coming from such a cultural crossroads, the brothers Kiradjieff spoke Macedonian, Bulgarian, Greek, Turkish and English. But they also created another language: the chili lingo that is still used today when ordering at a chili parlor. To aid in ordering, "chili spaghetti with cheese on top" was shortened to "three-way." This was done to let servers shout their orders quickly to the cooks during a busy lunchtime.

When asked how the coney originated, Tom Kiradjieff's son, Joe Kiradjieff, responded, "Well, where did the boat stop? New York City, near Coney Island." So in food ancestral terms, the New York–style hot dog is a distant cousin of the Cincinnati cheese coney. But that's where the similiarity ends. Not long after that customer requested shredded cheddar cheese on his chili spaghetti, the Empress also started putting cheese on top of its Coney Islands, and the cheese coney, one of the most popular chili parlor items, was born. Against the recommendation of their business advisor, the brothers Kiradjieff decided to raise the price of this new cheese coney from ten cents without cheese to twelve cents with cheese. But the crave for cheese coneys had already developed, and the extra two cents, even during the Depression, did not affect their sales.

Spiro Sarakatsannis, son of the founder of Dixie Chili and another former employee of Empress, said that the cheese coney did not come to northern Kentucky until the mid-1930s. Spiro's father, Nick, founded Dixie in 1929. So, by the mid-1930s, Cincinnatians could see a burlesque and have a three-way. They could see a girl dance the hoochie-coochie and a have a cheese coney in downtown Cincinnati. Former Cincinnati police chief Simon Leis's head would have been spinning.

John and Tom became naturalized U.S. citizens almost immediately after arriving in America, renouncing their allegiance to Macedonia. John loved his new country and never visited his homeland after moving to Cincnnati. He always said of his relatives back in Greece, "If they want to see me they can come to visit me here."

This is the naturalization certificate in 1926 of John Kiradjieff, recorded as Ivan Constantinoff Kiradjieff. He was five feet, seven inches tall and was listed as having a dark complexion. At the time, the brothers were living at 416 Clark Street in Cincinnati, which still stands in the downtown Over-the-Rhine neighborhood. *Courtesy of John Kiradjieff.*

Argiro started a trend among his brothers in Cincinnati. He went back home to find his wife, Katerina. He stayed there for several years, but when he came back to Cincinnati, he found that his two younger brothers were now very established. They graciously gave him a job as cashier in the 1940s at the new Empress location on Fifth Street.

Both Tom and John went back to Sofia, Bulgaria, to find their wives. Tom married Sika Petroff (1900–1989) in Toronto, Canada, and John married Mila Gandeva (1902–1989) in Paris, France. Tom's family chose the West Side of Cincinnati to raise their kids, living on Queen City Avenue, while John's family chose the Gaslight neighborhood of Clifton on Whitfield Avenue. Tom and Sika Kiradjieff's kids, Annette and Assen (or Joe), went to Western Hills High School and were involved in sports.

In his 1948 Western Hills senior yearbook, Joe was described as "Football manager, baseball, Maroon 'W,' Salesmanship club. A helping hand, fast

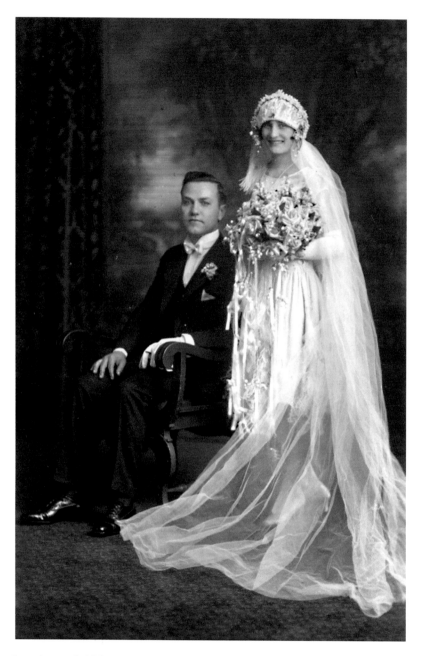

A newly married John and Mila Gandeva Kiradjieff pose in Paris for their wedding photo. The smiling bride dons a traditional Bulgarian headdress called a sokai, showcasing the heritage that she celebrated her entire life. This traditional headdress was banned by the Ottoman Turks, so these were preserved by hiding them in chests at home. *Courtesy of John Kiradjieff.*

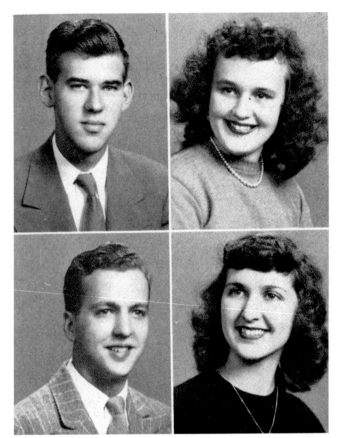

Assen (or Joe, top left) Kiradjieff's 1948 Western Hills High School senior portrait, with his signature (facing page). *Courtesy of the Price Hill Historical Society.*

talker—everybody likes Joe." Annette Kiradjieff's 1951 Western High senior yearbook said about her high school career, "Dramatics, Sr. Girls' Club, Modern Dance, Y-Teens, Spanish Club, Bowling; Counselor's Aide. Shy Grin, sweet temperament." Joe started working full time for his father at Empress in 1949, but Annette was never involved in the family business.

John and Mila's kids—Constantine (or Conny), Eddie and Johnny—went to Hughes High School in Clifton and were more into music. Mila's family had an extensive musical background in their native Sliven, Bulgaria. Her father, Vasil Gandev, played clarinet and was conductor in the Sliven Military Orchestra in Bulgaria. Mila's sister Vasia was a singer, and another sister, Ivanka, was a regular singer in the Sofia Opera. Ivanka even came to Cincinnati in 1937 to live with John and Mila, but she returned to Europe before the start of World War II.

Kinnemeyer, John: Silent observance, straightforward phrases, a laugh for every occasion.

Kiradjieff, Assen: Football Manager, Baseball, Maroon "W", Salesmanship Club. A helping hand, fast talker, everyone likes "Joe". *Assen Kiradjieff—Joe*

Kist, Jacqueline Louise: G.A.A., Y-Teens, Sr. Girls' Club, Modern Dance, Office Assistant. Cheery greetings, soft voice, earnest endeavor.

Klausing, Marian R.: G.A.A., Sr. Girls' Club, Spanish Club, Modern Dance, Y-Teens, Bowling. Every day's a holiday, mischievous eyes, fun in a crowd.

Klein, Frederick Joseph: Bowling, Maroon "W". Teasing way, medicine's messenger, an interest in cars.

Kling, Connie: Vice President of G.A.A., 6 Yr. Letter Girl, Latin Club Secretary, French Club, Y-Teens Ring Girl, Art Co-Editor of Annual, Breeze Staff, Life Saving Corp, Usher, Hiking Club, Student Council, Modern Dance, Sr. Girls' Club. Radiant charm, rates tops in everything, well deserved popularity.

Unfortunately, Mila's father passed away early, and the burden of raising a family of six children plus one orphaned grandson, Vasko, became her mother's. With an entrepreneurial spirit, Mila's mother, Maria Mineva, started a dressmaking and tailoring business that catered to the elite of Bulgaria.

Mila passed this love of music on to her own children. John Kiradjieff remembered his parents taking him, even as a young child, to the Cincinnati summer operas at the Cincinnati Zoo, where he'd sit on his mother's lap. He remembered how hot it was and how you could hear the bleating peacocks and the roaring elephants in the background. This turned he and his brothers into lifelong operaphiles. Although John doesn't play an instrument, he is a longtime Cincinnati summer opera series ticket holder. Eddie Kiradjieff in Boston plays violin, but it was their brother Conny who was the star.

John and Mila Kiradjieff sent Conny to Juilliard from 1953 to 1954 to pursue playing the violin. Cousin Joe Kiradjieff, who was in the service at that time, spent weekend passes visiting Conny in New York City and painting the town. Conny became a virtuoso violinist for the Cincinnati Symphony Orchestra for forty-nine years and was conductor and music director from 1967 to 1982. He prepared many generations of violinists at the Cincinnati Conservatory of Music for careers in music. If Cincinnati is the city that sings, then its chili is what makes people sing. Conny performed violin—with Leon Sarakatsannis, son of the founder of Dixie Chili, on piano—in 1963 at the Cincinnati College Conservatory of Music. Other chili families would have musical aspirations as well.

John Kiradjieff described an upbringing that was more Slavic than Greek in his family. His father loved Turkish coffee, and his mother would make it for him every evening when he got home. For the children, she would make lattes for breakfast all winter to warm them up, along with her turkish cookies. Argiro and his wife, Katerina, lived on the second floor of John and Mila's house on Whitfiled Avenue. John even plumbed in a new kitchen upstairs so they had their own privacy. However, Argiro's wife did not like America, and they moved back to Macedonia in the 1940s and had two daugthers, Slafka and Tsilka.

A fourth brother, the youngest, Ilias Kiradjieff, stayed back, and his grandsons, Ilias and Agamemnon Kiradjieff, opened an auto repair shop in the Argos-Orestikon area. Johnny Johnson of Camp Washington visited the area in 2012 and stopped in to visit with them. For those Kiradjieffs who stayed back in what would become northern Greece, they Hellenized the name Kiradjieff to Karatziss to fit in with the ethnic Greek population. Unfortunately, none has come to Cincinnati to understand the legacy that their family created in the city.

As kids, all three of John and Mila's boys worked in the chili parlor. Johnny, the youngest, was given jobs like counting plates and napkins. His other brothers worked the steam tables. Their father, Empress cofounder Joe Kiradjieff Sr., died in 1953, and his brother, Tom, took over. Tom's sons—Constantine, John and Ed—were not involved in the chili business after that. However, in the early 2000s, John sold his own packaged version of his father's chili, which he called "Dad's Famous Chili," to the Springdale and Milford Showcase Cinemas to serve on their coneys at the movie theater.

In 1962, Eddie Kiradjieff wrote his thesis for the University of Cincinnati, "Postwar Communization of Bulgaria," the homeland of their mother. This was perhaps inspired by a trip his brother John and his mother, Mila, went

on to Sofia in the 1960s to visit her sisters and relatives, whom she hadn't seen since immigrating in the 1920s. It's also an indication that the Cincinnati Kiradjieff family identified more with the Slavic-Macedonian and Bulgarian heritage of their parents than the Greek identity of later immigrants from their area.

In 1937, burlesque was becoming more and more sleazy, and the Empress was doing so much business that the brothers Kiradjieff decided it was time to move to a new location on Fifth Street, in a bustling entertainment and shopping district. Big theaters like the Albee on Fountain Square and Keith's were a few blocks away. The location was next to Foy's Paint and Wallpaper on the west and Columbia Oldsmobile on the east. Across the street was Cincinnati's Greyhound bus station. Neither the first nor second Empress location is standing today, as both were victims of the urban renewal affliction of the 1970s.

The Empress's former location became the Gayety Burlesque in 1940, and a Gayety Chili Parlor opened in the former Empress space. Demetrios L. Vaias (1904–1992), from Nestoria, Greece, operated the chili parlor into the late 1950s. The Gayety Burlesque closed in the early 1960s, and the Sunset Chili Parlor, owned by Sintov Mallah, took over the Gayety Chili Parlor site in 1965. The building was torn down in 1970, and the Main Library of Cincinnati and Hamilton County today stands on the ancestral site of Cincinnati chili.

In 1953, John Kane, the owner of the Gayety Burlesque, said, "In the long run the best thing to do about burlesque is to buy a ticket at the box office, and check your brains with your hat, and have a hell of a good time." An ad on the side of a building downtown for the Gayety showed a scantily clad dancer kicking her legs and advertised a midnight show every Saturday, as well as noted hours of operation from 11:30 a.m. to 11:00 p.m.

The new Empress location on Fifth Street became a popular lunch destination for downtown professionals. It was only one block away from the large Procter & Gamble headquarters and other large downtown businesses. Between the business lunch crowd, weekend theatergoers, shoppers and the constant flow of Greyhound bus riders, this location was a gold mine for the Kiradjieffs. The new spot had seventy-two tables and one large L-shaped counter. At its height, the Fifth Street location served 3,600 cheese coneys and nine hundred to one thousand people in a one-and-a-half-hour lunch period. There was so much traffic in the parlor that the linoleum floors wore quickly and were replaced periodically.

In 1962, after Joe had returned from service in the Korean conflict, his father became paralyzed from a stroke, and Joe took over the operation at

This is a photo of the second Empress location on Fifth Street, taken in about 1954. Today, this is the site of the Chiquita Building. *Courtesy of Joe Kiradjieff.*

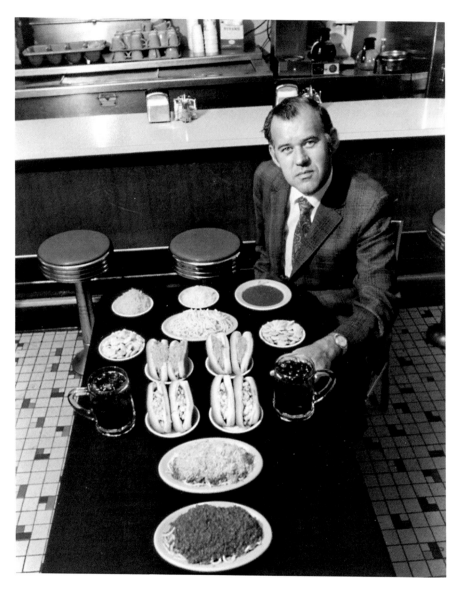

This photo by the Bob Acomb Advertising Agency shows Joe Kiradjieff at the Fifth Street Empress location, with the steam table behind him. *Courtesy of Joe Kiradjieff.*

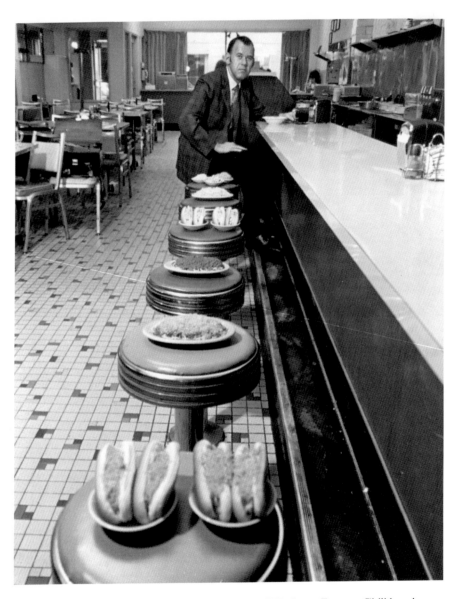

Another view shows the lengthwise perspective of the Fifth Street Empress Chili location. *Courtesy of Joe Kiradjieff.*

Fifth Street. At that time, Thursday was ladies' day. All the secretaries from Procter & Gamble next door and other downtown businesses would come in for lunch. None of the all-male staff missed work on Thursdays.

In the 1970s, Empress tried its hand at advertising. It was about this time that other chili parlors were franchising and using big-dollar marketing to promote their Cincinnati chili brands. Using a local advertising agency, Empress created an ad campaign using a pretty blonde "Empress" model with a tiara that was placed in the Delta Air Lines in-flight magazines. But that was its last great campaign. Skyline and Gold Star both surpassed Empress with massive marketing budgets to create print, TV and radio ads, and both had their own jingles.

Although Joe discouraged his all-male staff from asking the female clientele for dates, he met his wife, Carol Wiess, at Empress in 1969. Carol worked for Cincinnati Gas & Electric in the legal department. One day, she came in with another female co-worker for lunch. After clearing the table for the girls, Joe broke his own rule by lingering and flirting. The end result was a date with Carol. Instead of dinner, which they had sort of just had together, she invited Joe to watch her play softball in Covington later in the week with her Price Hill team. When asked where she lived, he found out that she lived three houses from the corner of Queen City Avenue, very near where Joe lived with his parents. Joe made it to his future wife's first softball game, and the rest is history.

Empress sponsored an A league women's softball team for many years, and it traveled the country. The team was known in Las Vegas, Detroit, San Francisco, Nashville and Florida. Most of the women were schoolteachers, and in the off season, they would rotate practicing indoors at their respective school gyms around town. Empress also sponsored a bowling team, on which Joe played. But the bowling didn't last as long as the softball sponsorship.

It was through this bowling league at Stumps Bowling Lanes on Bridgetown Road in Western Hills that the first Empress franchise came about. At the time, Cliff Newman used to bowl against Joe Kiradjieff. Newman ran a Pasquale's Pizza, started by his wife's brothers, Pat and Vinnie Gramaglia, in 1954. He asked Joe if he could sell Empress chili at his Pasquale's restaurant. Joe, having no experience in franchising, talked to his lawyers and, after their blessing, set up Newman as the very first Empress franchisee in 1962. To add some perspective, this was before Gold Star started in 1965 and the same year that the second Skyline franchise was opened by Adeeb Misleh in Camp Washington. One side of the restaurant was a Pasquale's, and the other was an Empress Chili, but they shared a dining room so customers

could order both pizza and chili. The location was open until 1979. Cliff Newman's son, Steve Newman, now operates the Werk Road Empress Chili, which opened in December 2011.

It was almost as if the Kiradjieffs had an unwritten manual on how to open a Cincinnati-style chili parlor. This secret manual might have read, "Choose a location next to or very near a theater, serve a minimal menu of already prepared foods in an open kitchen, have counter service, don't serve alcohol and make it a family atmosphere." As scores of their countrymen immigrated to Cincinnati, the Kiradjieffs gave them jobs in the parlor and helped them navigate their new homeland. A number of them learned the chili business and established their own parlors. The two Nicholases—Sarakatsannis and Lambrinides—operated from this manual. Sarakatsannis worked at Empress in the 1920s before leaving and opening Dixie Chili in Newport, Kentucky, in 1929 near the Strand, State and Hippodrome Theaters. Nicholas Lambrinides, founder of Skyline Chili, worked as a cook and counter man at Empress on Fifth Street. His two sons, Bill and Chris, worked for Empress as well, after they graduated from Western Hills High in 1946. Then, in 1949, with their brother Lambert and their father, they opened the first Skyline Chili in Price Hill. Bill , Chris and John Lambrinides went to Western Hills High School at the same time as Joe Kiradjieff. Harry Vidas worked at Empress until he opened Chili Time in St. Bernard in 1943. Thomas Manoff worked at Empress in 1938 before opening his Tip Top Hamburger Shop on Glenway Avenue in 1946.

The Empress business continued to grow, and in the mid-1950s, they opened their first commissary on Twelfth and Vine in downtown Cincinnati. This served the Kroger's business, which Empress landed in 1959 and held for fifty years. In 1964, Empress opened its current commissary at 10592 Taconic Terrace in Woodlawn, a central suburb of Cincinnati. This commisary serves the several Empress restaurant locations, non-chili parlors that serve Empress chili, and the frozen food business for retailers like Remke and IGA. Also, at one time, it serviced contracts with the Beach Waterpark and the River Downs racetrack.

In 1971, the city took the block where the Fifth Street Empress restaurant stood, along with the Art Deco Greyhound bus station across the street. Columbia Oldsmobile fought the city and lost, surrenduring to urban renewal. Of all the next Empress locations, Joe Kiradjieff said that the downtown location was truly the best. No doubt it was where many good memories for him and his family were formed.

After the first franchise, others popped up around the city. On the West Side were locations in Western Hills, Delhi and White Oak. On the East Side, a

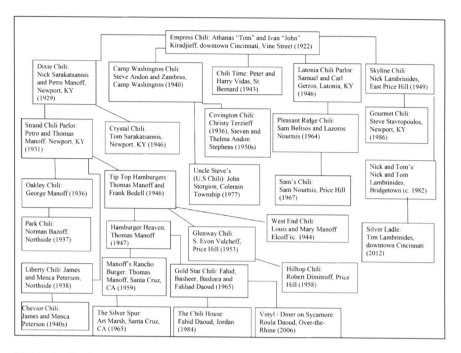

This is the Cincinnati chili family tree, showing all the chili parlors that have sprung from workers at the original Empress Chili Parlor. *Created by author.*

Mount Lookout Empress opened at 3164 Linwood Avenue in Mount Lookout Square near an old movie theater. The space is now Ruthals Thai restaurant. Locations existed in Surrey Square Mall in Norwood; New Richmond, Ohio; Harrison, Ohio; a third location in downtown Cincinnati; and Sutton Place in Westchester. In Kentucky, there were locations in California, Melbourne and Highland Heights. Empress even found its way to Indiana, opening up stores in Lawrenceburg and Greendale. There were also three locations outside the Interstate 275 loop in the tri-state. Locations in Dallas, Texas; South Carolina; and Deland, Florida, brought the Empress Chili brand out of the region. Today, only a Hartwell and Bridgetown Empress Chili location exist in Cincinnati, along with one in Alexandria, Kentucky.

Owned by Steve Newman, the Bridgetown Empress is not a franchise. It is nestled next to the Pirates Den and owned by his sister and brother in law in the Cincinnati Marketplace mall between Werk Road and Glenway Avenue. Like his father's Empress, which shared a dining room with a Pasquale's Pizza, Steve plans to serve chili through a connecting window to the Den next door.

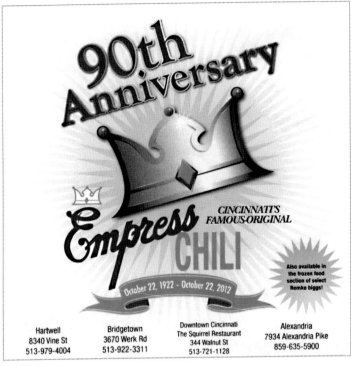

Left: This is the Empress advertisement celebrating the ninetieth anniversary of the opening of its first chili parlor at the burlesque theater. *Courtesy of Joe Kiradjieff.*

Below: The author enjoying a chat with Cincinnati chili royalty Joe Kiradjieff at the Bridgetown Empress Chili on Werk Road. *Author's collection.*

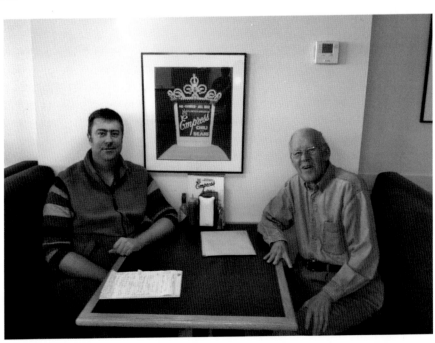

In 2009, in less than a few months, five Empress franchisees decided to close their stores. So, after eighty-seven years of family operation, Joe Kiradjieff decided to retire from the Empress chili business. He sold to Joe Papakirk, a local lawyer. Papakirk's wife, Mary, is the daughter of Johnny Johnson, the longtime owner of Camp Washington Chili. Papakirk came to Empress with a fresh perspective and a strong desire to grow the original Cincinnati chili parlor. Papakirk's business plan continues to unfold for the founding brand of Cincinnati chili. For the younger generation, the Empress brand is less well known because they have not seen as many storefronts, but an older crowd remembers. Papakirk plans to bank on the history to strengthen the brand.

In addition to the franchise locations, several restaurants serve Empress chili on their menus. The Red Squirrel Restaurant in downtown Cincinnati and the New York Deli in Mount Washington, across from the original Gold Star Chili, are two.

On October 22, 2012, the Empress Chili Parlor celebrated its prestigious ninetieth anniversary. In the midst of the Great Depression, two Slavic Macedonian immigrants created a brand-new food category that has grown and grown. It has created thousands of jobs, millions of memories and countless good times. For baby boomer Cincinnatians, Empress defines Cincinnati chili. It wasn't until the mid-1960s that both Skyline and Gold Star Chili franchised in nearly every neighborhood. Many remember the spiciness of Empress Chili along with having to be careful not to swallow a whole chili pepper, which they stewed in the chili and didn't remove before serving.

Joe Kiradjieff continues to be active in the business as an advisor. Both Joe and his daugther, Tracy Kiradjieff Evans, said that the Empress recipe has not been modified since it was created in 1922 by Tom and John Kiradjieff. Tom used to say, "If you change the recipe you might as well lock the front door." What customers eat at Empress today is the same chili they may have been ordering in 1922 on Vine and in the 1950s on Fifth Street. What makes the Empress recipe unique is that it is served with whole red peppers in the chili. No other Cincinnati-style chili uses whole peppers. Joe thinks that this spiciness is the best part of the chili. Many Cincinnatians would agree.

Natives are indeed rallying for an Empress Chili comeback. As a legacy town, we like our hometown favorites. It is truly nice to still have the anchor chili parlor that created our favorite food category.

DIXIE CHILI

For the founder of Dixie Chili, Nicholas D. Sarakatsannis (1900–1984), it must have been fate that brought him to Cincinnati. His early years were an odyssey of journeys, taking him from war-torn Macedonia to New Hampshire and many Ohio cities while he chased his part of the American dream. Whatever the reasons for finally landing in the area, northern Kentuckians are thankful that Nicholas found his way to Newport, Kentucky, to perfect the local chili recipe.

Dixie Chili is considered by many northern Kentuckians to be the best Cincinnati-style chili parlor in the area. Funny, isn't it, that across the Ohio River it's still referred to as "Cincinnati chili"? Well, that's because of its legacy. Along with being the only chili parlor still operating from its original 1929 location, and the only one whose secret recipe is solely controlled by the founding family, its founder was also the first Empress employee to break off and found his own chili parlor.

Nicholas D. Sarakatsannis was born in 1900 in the same area of Macedonia where the Kiradjieff family originated, Argos-Orestikon. The family name comes from a name given to roaming shepherds, Sarakatsanni, who spent their summers in the mountains and their winters in the lowlands of western Macedonia. The family lived in a small two-room house in a mountainous village that had only one exterior wood-burning oven that was shared by everyone. The village was surrounded by olive groves and a river.

Although the Greeks had liberated the region, Turkish guerrillas were terrorizing the area and massacring entire villages. Nicholas's mother,

fearing for her sons' lives, sent Nick and his brother, Tom, to a neighboring village for safety. On their flight to the other village, a rainstorm swelled the river they had to cross. This was truly a divine event, for after the rains subsided, the brothers learned that everyone in the village where they were heading was killed.

After such a near miss, Nick decided to leave his Macedonian homeland, and at age fifteen, with no knowledge of English, he made the Atlantic crossing that so many of his countrymen were making. He found his way from New York City to New Hampshire, working in a shoe factory and a woolen mill for one dollar per week. Despite these meager earnings, Nick found in his budget enough money to send back home to his widowed mother in Macedonia.

Two years after landing in New Hampshire, surely after hearing of the Macedonian and Greek community there, Nick made his first trip to Cincinnati. While looking for work within this growing immigrant community, Nick was recognized by his father's godson, who helped him land a job at a candy store on Fifth and Elm Streets in downtown Cincinnati. Here Nick worked the grueling hours of 6:00 a.m. to 11:00 p.m. with no days off. After two years under these trying conditions, Nick and his fellow employees were denied a raise, and they all walked off the job.

The next stop on Nick's chili odyssey was Portsmouth, Ohio, 104 miles east of Cincinnati along the Ohio River, where he again found work in the candy business. He met some fellow immigrants there who were operating a failing hot dog stand. He brought them back to Cincinnati, then the porkopolis of the Midwest, where they naturally obtained a better-quality hot dog, and their business increased.

Always on the lookout for better opportunities, Nick then moved to Marion, Ohio, with $300 saved from his candy making job. In Marion, Nick operated a Coney Island stand from a place he rented from President Warren G. Harding's brother-in-law. Then, after a few years, he moved on to Mansfield, Ohio, where he operated a candy store and a restaurant he called The Lark. Nick said of those days, "We worked hard and what nickels we got, we saved," echoing a common situation among new immigrants building their future.

Missing his mother after a ten-year absence from her, Nick decided to go back to Macedonia for a visit. He came back from this trip with a wife, Melanthia, who bore him six sons—Jim, Leonidas, George, Chris, Panny and Spiro. Like the Lambrinides family of Skyline Chili, the six Sarakatsannis sons would provide good manpower with which to grow the chili business.

In 1928, with three young sons, Nick and Melanthia traveled north to Dayton, Ohio. Unable again to find the next big opportunity, Nick came back to Cincinnati for the third and last time. We have to thank Dayton for turning Nick away, as there might have been a Gem City Chili Parlor instead of a Dixie. Nick found his way to the Empress, then on Vine Street in the burlesque theater, and told the owner, fellow Macedonian Tom Kiradjieff, that he needed a job. The response was, "Put on an apron."

After working split shifts for the Kiradjieff brothers at Empress Chili for several weeks, the enterprising Nick decided that he could formulate his own Cincinnati chili recipe. Not wanting to steal business away from his fellow countrymen, Nick took a streetcar tour of the area to scout a location for his chili parlor. He idolized Tom Kiradjieff and even referred to him as "an Edison, a Firestone," so he would not choose a location to compete with the Empress. Nick found bustling Monmouth Street, surrounded by three theaters in the heart of Newport, Kentucky's "Sin City" of adult clubs and casinos. With a partner, fellow Macedonian Petro Manoff, he started Dixie Chili in a small eight-foot-wide storefront between two buildings at 733½ Monmouth in the former Odeon Shoe Parlor. Petro would only last a year or so as partner before splitting to start his own restaurants. But that would be the making of another Cincinnati chili legend.

In this small original location, Nick did everything from make the chili to serve it, often working eighteen-hour days. Most restaurants on Monmouth Street were open twenty-four hours a day then to cater to the after-hours clubs and nightlife, and Dixie was no different. Nick remembered making nine gallons of chili on his first day. Dixie served breakfast too and may have been the first chili parlor to serve Cincinnati chili over eggs. A Cincinnati chili omelet comforted many a loser at one of Newport's many casinos.

In the early days, the restaurant had slot machines, like all the other businesses on Monmouth Street. The slots provided another revenue stream during the depression. The chili parlor was next door to the Hipp Theatre, across the street from the State Theatre and down the street from the Strand. Early performers in the 1930s at the Hippodrome became customers at Dixie. A young Bob Hope, George Burns and Red Skelton all came into the parlor late after their shows at the Hipp. Bob Hope would come in and eat two coneys without cheese and a water because that's all he could afford. In the 1950s, the Sarakatsannis purchased the aging Hipp and turned it into the Hip Car Wash, which they ran until they razed it for a parking lot.

Later celebrities would patronize the Dixie as well. Larry Flynt comes into the Newport Dixie whenever he is in town. Local food mogul Buddy

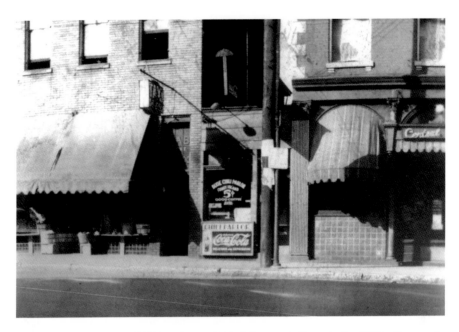

This is the original Dixie Chili location at 733½ Monmouth Street in the 1920s. *Courtesy of Spiro Sarakatsannis.*

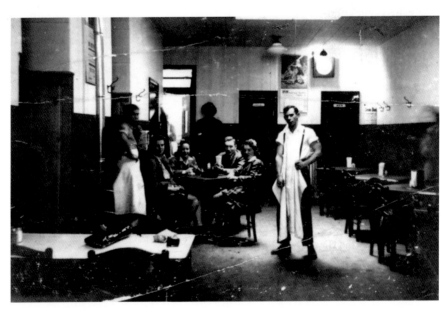

An early photo of the inside of the original Dixie Chili Parlor shows a waiter pausing to socialize with his female customers. *Courtesy of Spiro Sarakatsannis.*

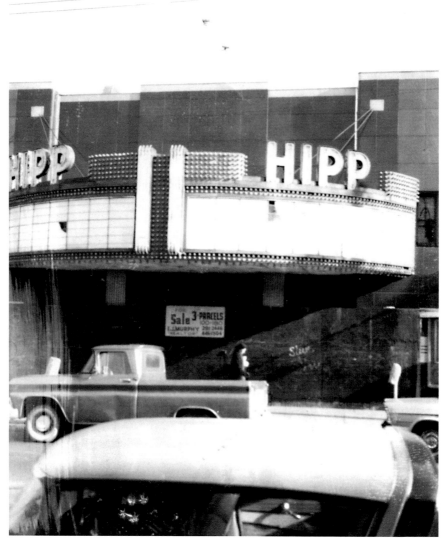

This photo shows the Hipp Theatre next to Dixie Chili in Newport, Kentucky, shortly before it was purchased by the Sarakatsannis family and turned into the Hippo Car Wash. *Courtesy of Spiro Sarakatsannis.*

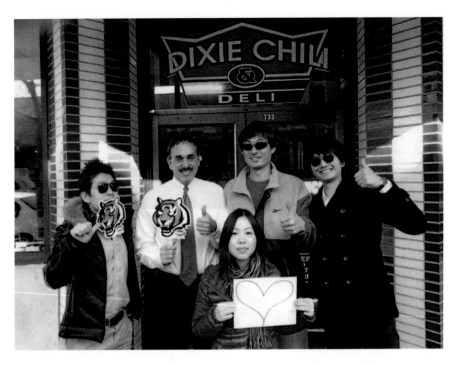

Above: Newport Dixie Chili owner Spiro Sarakatsannis is surrounded by a group visiting from Japan in front of the Newport chili parlor. *Courtesy of Spiro Sarakatsannis.*

Opposite, top: Nicholas Sarakatsannis, founder of Dixie Chili (seated center), poses with all of his sons for a family portrait. *Courtesy of Spiro Sarakatsannis.*

Opposite, bottom: Melanthia and Nicholas Sarakatsannis at an Optimist party at the old Wiedemann Brewery rooftop garden in Newport. Nicholas was very active in the Newport Optimist Club. *Courtesy of Spiro Sarakatsannis.*

LaRosa and his son visit periodically to have their favorite Cincinnati-style chili. Groups of Japanese tourists visiting Toyota also like to patronize the Dixie.

The family settled in to a home in Fort Thomas at 79 Bivwale. All of the sons had something besides the chili business. Leon Sarakatsannis was a concert pianist and performed with fellow Cincinnati chili legacy family member Conny Kiradjieff, son of Empress founder John Kiradjieff. Both Leon and George served in the U.S. Air Force in the 1950s. James worked as an agent for Provident Mutual Life Insurance. Spiro, before going into the family business, was a chief psychologist for the U.S. Navy. But the chili business proved to be profitable and a good career for the brothers.

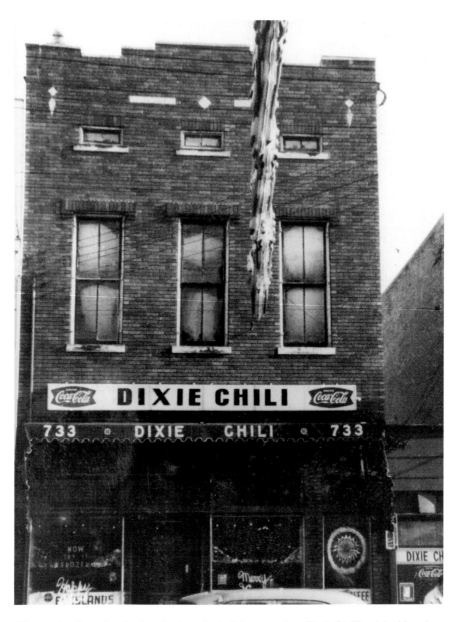

After moving from the alley location into the building next door, Dixie Chili's original location in Newport has expanded to a moderate-sized chili parlor. *Courtesy of Spiro Sarakatsannis.*

The newly renovated Dixie Chili Newport location certainly has the 1950s American diner feel that many Cincinnati-style chili parlors share. *Courtesy of Spiro Sarakatsannis.*

Food rationing during World War II forced Nick to limit his hours of operation. So, always enterprising, Nick contributed to the war effort by selling $3 million in war bonds, something that gave him great pride. Very active with his family and his community, Nicholas was a member of the Newport Optimist Club. After a long life, Nicholas D. Sarakatsannis, "Papa Nick," died on October 29, 1984, and was laid to rest at Evergreen Cemetery in Southgate, Kentucky. His legacy lives on through his sons.

Today, Dixie Chili is a thriving second- and third-generation family-owned and family-operated business. Owned by Nicholas's two sons Panny and Spiro, there are three locations: the original in Newport; Erlanger, now run by Panny; and Covington, run by Panny's wife, Judy. Their son, Mark, also works at all the Dixie locations. Andrew, son of George and Marie, was the manager of the commissary and quality control supervisor, and their daughter, Melissa, ran the marketing department for a while.

The Erlanger location at 3716 Dixie Highway was opened in 1960 by Chris and the Covington location at 2421 Madison Avenue in 1967 by Panny. George and Marie ran the flagship location until Spiro took over. One franchised location in Independence, Kentucky, at 4185 Richardson Road, closed after nearly twenty years of operation. Another location also existed at 7911 Mall Road in Florence, Kentucky.

In 1982, after careful deliberation, Dixie invaded Ohio with its first chili parlor north of the Ohio River. It chose the area around Short Vine in Corryville, near the campus of the University of Cincinnati, in what was called University Plaza. This was a busy entertainment district anchored by bars like Sudsy Malones and a former movie theater turned concert hall called Bogarts. Spiro was the manager and oversaw the investment of $300,000 to renovate the former Fifth Third Bank office into a chili parlor. The finished location served up to eighty customers, had a drive-through window and employed twenty-five people from the university area. Cincinnati Reds owner Marge Schott owned the property and was Dixie's landlord. A few years later, though, when a Blockbuster video store offered her better rents, she evicted Dixie Chili, ending their foray into Ohio chili parlors.

The Dixie, like the Empress, was a proving ground for those who opened other chili parlors. A friend of Nick's, Loucas Vesoulis (1928–2001) from Nestoria, Macedonia, worked as a cook at Dixie Chili in the late 1950s. He had a disagreement with Nick and left Dixie Chili to work for the Daoud brothers at Gold Star Chili. At Gold Star, he became the chief chili chef at their commissary and helped them install their cook/chill system that allowed them to make large amounts of chili and freeze it for packaging. Spiro said that Vesoulis has a lot to do with what Gold Star chili is today.

Like any foodie, owner Spiro will tell you that the magic of Dixie Chili is its high-quality, fresh ingredients. Made from 96 percent fat-free beef chuck or loin, Wisconsin cheddar cheese, sweet Bermuda onions and 100 percent seminola wheat pasta, Sarakatsannis said that it's better than reconstituted chili. Its USDA-inspected commissary is on site at the Newport location. Every day, 150 gallons of Dixie Chili are made at this commissary, supplying the three locations and the growing retail business in local and regional grocery markets. Dixie sends its chili made at the commissary to Worthmore Chili company in Cincinnati to be canned for its retail business. Dixie Chili is available as premium chili and as a vegetarian version at Walmart in seven states. Dixie Chili is also a Kentucky Proud product, meaning that all its ingredients are sourced from farmers and producers in the commonwealth of Kentucky.

A group of smiling chili waitresses poses in the 1960s in front of Dixie Chili. *Courtesy of Spiro Sarakatsannis.*

This shows a proud Spiro in his newly opened Corryville Dixie Chili location near the University of Cincinnati in 1982. *Courtesy of Spiro Sarakatsannis.*

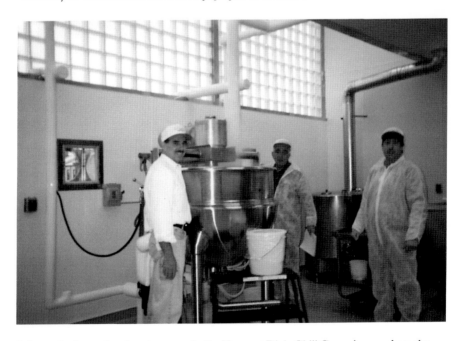

Spiro and others take a break to pose in the Newport Dixie Chili Commissary, where the magic happens. *Courtesy of Spiro Sarakatsannis.*

Spiro said that people think that it's the spices that can cause indigestion after eating three-way chili. However, he claimed that it's not the spices but rather the fat content of the meat. He uses the leanest cuts to prevent this, and he thinks that his elderly customers are thankful.

The secret blend of Dixie Chili spices is mixed only by a family member at a locked spice room in the back of the Newport restaurant. I had the rare opportunity to inspect the interior of the Dixie spice room, and the aroma is immense. Smelling strongly of paprika and cumin, it is like walking into a Turkish spice bazaar. Mixing the spice blend is something that takes constant tweaking. Spices are usually shipped in oil, and when companies change the concentration of spices in oils, this means that the ratios of the spice blend have to be recalculated. So, constant monitoring of concentrations and quality is something about which Spiro is hypervigilant. For a few years, Spiro even supplied spices from Dixie to fellow chili engineers at Covington Chili.

Spiro was contacted by the *Food Network Magazine* in 2012 and asked to provide a recipe for Cincinnati chili. He, of course, would not give out the full version, and he keeps his father's recipe in a locked vault. Spiro did, though, part with the following Dixie-like recipe, which was printed in the January 2013 *Food Network Magazine*. It gives us a small window into the secret recipe:

CINCINNATI-STYLE CHILI
Cook time: 2 hours
Serves 8

4 tablespoons extra-virgin olive oil
2 sweet onions (such as Vidalia), finely chopped, plus more for topping
2 pounds ground beef chuck
½ teaspoon each kosher salt and finely ground black pepper
4 cloves garlic, minced
1 15-ounce can tomato sauce
2 medium tomatoes, diced
¼ cup apple cider vinegar
¼ cup chili powder
2 tablespoons paprika
1 tablespoon ground cinnamon
2 tablespoons ground cumin
½ teaspoon ground allspice
¼ teaspoon ground cloves
¼ teaspoon cayenne pepper

1 pound spaghetti, cooked
pinto beans and grated cheddar cheese, for topping
oyster crackers, for serving (optional)

Heat the olive oil in a large, heavy pot over medium-high heat. Add the onions and cook, stirring until translucent, about 5 minutes. Transfer to a plate. Add the ground beef to the pot, sprinkle with about ½ teaspoon each salt and black pepper and cook, breaking up the meat with a wooden spoon until no longer pink, about 4 minutes. Remove from the heat and return the cooked onions to the pot; stir in the garlic.

Combine the tomato sauce, diced tomatoes, vinegar, chili powder, paprika, cinnamon, cumin, allspice, cloves and cayenne in a bowl; add to the pot along with 1 cup water and stir to combine. Bring to a simmer over medium-low heat and cook until the chili is slightly thickened, about 1 hour, 30 minutes.

Serve the chili over spaghetti; top with chopped onion, pinto beans and grated cheddar cheese and serve with oyster crackers on the side.

One of the most well-known ingredients, the bay leaf, is omitted from being stewed in the chili in this recipe. When I asked Spiro, he laughed and said, "Well I didn't say I was going to give the real recipe!" He did, however, specify apple cider vinegar, which is an Empress legacy. Spiro thinks that some of the other more well-known chili parlors use sherry vinegar or sherry to impart the sweetness. Most Greek and Macedonian dishes like pastichio, he relayed, are cooked with white wine or, less frequently, red wine. He also adamantly denied using cocoa or chocolate in Dixie's chili. The presence of chocolate in Cincinnati chili is a myth.

It's no surprise that Dixie Chili supports the troops. The majority of the Sarakatsannis brothers are United States veterans. In November 2012, Spiro sent three cases of Dixie Chili to Sergeant Tom "Maniac" Schulte and his squadron in Kandahar, Afghanistan. In thanks, Schulte sent back a flag flown during one of their missions in Afghanistan, which will be displayed at the original location in Newport. Schulte said of Dixie:

My Daddy grew up in Newport, and I have been coming to your place on Monmouth Street since I was a little kid. My "Pops" would drive us from Ashland, Kentucky, or Wheelersburg, Ohio, to go to a Reds game, and we always came and visited your place before the game. Three ways and cheese coneys are "in my blood" and having a taste of home makes Kandahar, Afghanistan, a bit more tolerable.

Stopping in at "the Dixie" is a longtime family tradition in northern Kentucky. Generations of chili eaters have been choosing Dixie Chili for more than seventy-four years. Many wonderful family memories have been created in the Dixie Chili Parlor. Kids who grab a coney on a Friday after the game know that their grandparents did the same thing as teenagers. Many cars full of college kids sate their late-night coney fixes at the Newport location until 3:00 a.m. on Fridays and Saturdays. The Sarakatsannis family says, "True aficionados of chili know the best Cincinnati-style chili comes from the oldest chili parlor in Northern Kentucky, Dixie Chili and Deli."

CINCINNATI-STYLE CHILI IN KENTUCKY

Dixie Chili is rightfully considered a staple of northern Kentucky's chili history. Its legacy brought Cincinnati-style chili into northern Kentucky. But there are many other chili parlors across the Ohio that have held their own over the years. And like Cincinnati, many have come and gone. All have contributed to the "northern Kentucky chili consciousness" (NKCC).

The counties of northern Kentucky, like Cincinnati, are made up of many small neighborhoods. Each of these unique boroughs had its own theater and its own neighboring chili parlor. Some have been the singular chili parlor in the neighborhood since before the Second World War, guarding its chili recipe as if it were a sacred relic. Others are more recent additions.

Middle Kentucky has its Bourbon Trail, Southern California has its wine country and Cincinnati has its Chili Highway. Glenway Avenue on the West Side of Cincinnati is considered the Chili Highway because of the number of chili parlors that existed from the 1940s to today. Similarly, northern Kentucky has not one but three equivalents to this Chili Highway. They are Monmouth Street in Newport, Madison Avenue in Covington and Route 8 (called Sixth Avenue in Dayton and Fairfield Avenue in Bellevue). All three thoroughfares once housed lively entertainment districts with numerous movie theaters, confectioneries and, in some cases, casinos and adult entertainment.

Kentucky chili heads have four of the five oldest continually operating chili parlor locations in the Greater Cincinnati area: Dixie Chili (1929) and

Strand/Crystal/Gourmet Chili (1931) on Monmouth Street, Covington Chili on Madison Avenue (1936) and Dayton Chili Parlor/Christofields on Sixth Avenue (1939). Cincinnati's Park Chili (1937) in Northside is the oldest continually operating chili parlor location on the other side of the river.

NEWPORT'S CHILI LEGACY

Of Newport's Monmouth Street chili parlors, Dixie Chili blazed the chili trail first in 1929. Then, in 1931, Petro Manoff, a former partner of Nick Sarakatsannis of Dixie, opened the Strand Chili Parlor one block south of Dixie at 843 Monmouth Street. Manoff and his son, Thomas Sr., ran the Strand until it was sold to the Thomas Sarakatsannis family in 1946; they then opened as Crystal Chili Parlor. The location at number 843 has been a chili parlor for more than eighty-four years, making it the second-oldest continually operating chili parlor in either Cincinnati or northern Kentucky.

Unfortunately for the Nick Sarakatsannis family, the opening of Crystal Chili Parlor started a rift between family members that has only recently been mended by second and third generations. Imagine running a competing business only one block away from your only other sibling in a new country. Tom Sarakatsannis operated Crystal Chili from 1946 to 1986 with his four sons—Art (1914–2002), James, Charles (1926–2011) and Phillip. A daughter, Lorrain Sarakatsannis, was not actively involved in the chili parlor.

Tom brought his wife, Stella, and sons Art and James to America in 1916, settling in New Hampshire with brother Nicholas Sarakatsannis. By the early 1940s, Tom had brought his family to northern Kentucky, following his brother. Tom's sons Charles and Art Sarakatsannis had operated the Crystal Grill in Cincinnati at 244 West McMillen in 1944, but a Newport location proved a better choice when the Manoffs decided to sell their Strand Chili Parlor. Tom and his family settled into a homestead at 625 Maple, where many of the children lived, even after marrying.

Charles Sarakatsannis served in the U.S. Navy and then attended Chase Law School before helping out with the family business. He taught at Porter Jr. High School for twenty-seven years and served as Newport city commissioner for twelve years during its boomtown years. The latter job gave his family's chili parlor a good standing with the local police. Just like Dixie Chili and Strand Chili Parlors, they also had slot machines in their parlor to help with

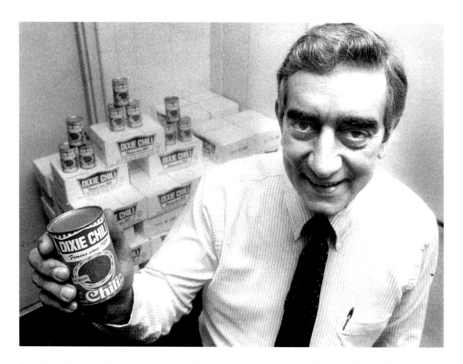

President George Sarakatsannis proudly poses with cans of his Dixie Chili in 1984. *Courtesy of the Kenton County Public Library.*

added revenue. They also often remained open around the clock to serve the gaming crowds. For Newport's economy, gaming generated revenues in excess of $100 million. That figure does not include the money that patrons spent in the shops and restaurants nestled among the clubs and casinos, like the Monmouth Street chili parlors. Within Newport's central business district, restaurants, grocers, jewelers and other mainstream stores competed for gaming patrons' greenbacks, and from grocers to barbershops, nearly all had at least one gaming device on site. Although Newport's upscale gaming years ended in 1961, local police battled backroom gambling joints until the 1970s.

In the 1970s, Crystal Chili ran an ad in local newspapers featuring Phillip Sarakatsannis III eating a coney and saying, "Eat at Crystal Chili and grow up big and strong like me." Crystal definitely created its own loyal following in Newport, and many were sad to see it close in 1987 when it was sold.

Despite stiff competition, several other Monmouth Street chili parlors decided to open, mainly to share a piece of the gaming money floating around Newport. The Coney Island Restaurant at 609 Monmouth and the Hipp Chili Parlor at 709 Monmouth were both operating in the early 1940s.

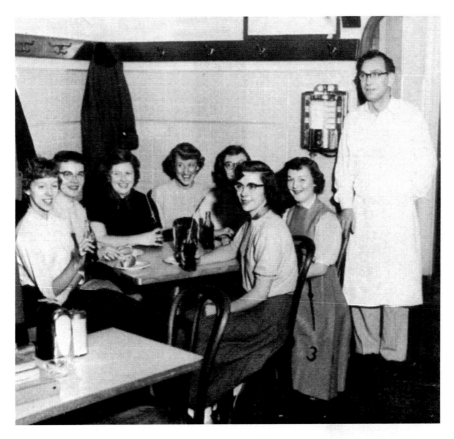

An early 1940s photo shows the interior of Crystal Chili Parlor, owned by Tom Sarakatsannis, brother of Nicholas Sarakatsannis of Dixie Chili. *Courtesy of the Kenton County Public Library.*

Neither was able to compete with Dixie and the Strand, and both closed after only a few years.

In the 1980s, the Sarakatsannis brothers were aging, and it was time to retire from the chili business. In 1986, they sold the location that had been the Strand Chili Parlor and Crystal Chili Parlor to Steve Stavropoulos, and it became Gourmet Chili. Steve had immigrated to Cincinnati from Agios Demetrios in Laconia, Greece. His mother, Maria Georgantonis Stavropoulos, had a brother, Tom, who lived in Clifton and whose sons, John and Pete Georgeton (Americanized from Georgantonis), had opened the Clifton Skyline in 1966 after being trained at the original Skyline in Price Hill.

This gave Stavropoulos a starting-off point, and so he worked full time at the Clifton Skyline with his cousins. In his precious "spare" time Steve

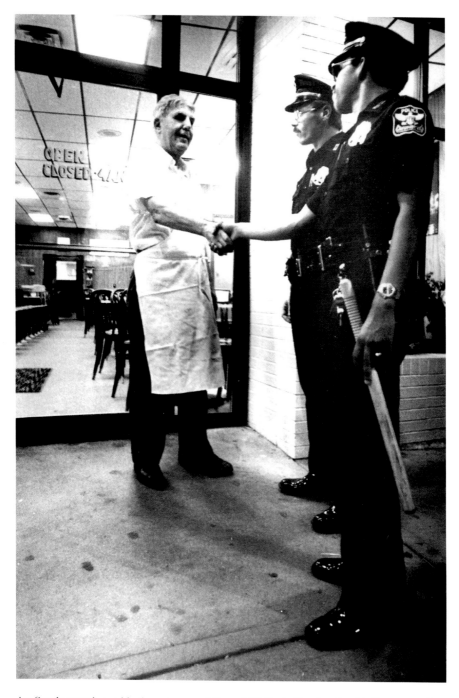

Art Sarakatsannis outside the entrance of Crystal Chili, shaking hands with Newport police officers. *Courtesy of the Kenton County Public Library.*

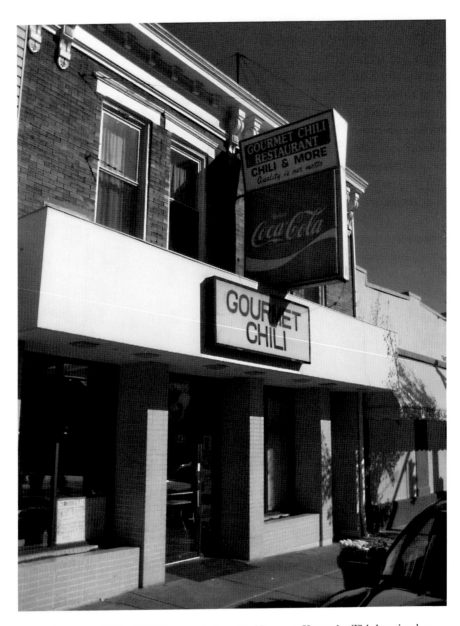

This is Gourmet Chili at 843 Monmouth Street in Newport, Kentucky. This location has been a chili parlor since 1931, starting with the Strand and then becoming the Crystal Chili Parlor, making it the second-oldest continually operating chili parlor in Cincinnati and northern Kentucky. *Photo by author.*

worked other jobs to build a nest egg for his family. He married Angela Batsakis, daughter of Kyriakos and Metaxia Batsakis, in his native village on August 21, 1977. They eventually became proud parents of three sons: George, Kiriakos and Theodore.

Stavropoulos fell in love with food preparation during his years at Skyline, and this led him to the opening of his Gourmet Chili Parlor. George took over the chili parlor after his father's passing and now shares ownership with his wife, Angela.

Gourmet's founder, Steve, was an active member of the St. Nicholas Greek Orthodox Church, along with so many other chili pioneers. He founded the Agios Demetrios Society within the church and served many years as its vice-president. As a humble, inquisitive and creative man, he loved life and had many interests. Before immigrating to America, he held a variety of jobs, again like many of the chili pioneers did. He spent time in Australia, was in the military and was a farmer. While in the military, he tested excellently as a parachutist and garnered a diploma.

COVINGTON CHILI PARLORS

Covington Chili was the pioneer in anchoring Madison Avenue chili parlors in Covington's entertainment district. The parlor was established in 1936 at 703 Madison Avenue. Even though it has a loyal following of regulars in the region, it does not usually come up in discussion of Cincinnati-style chili parlors. Covington Chili is nearly across the street from the newly renovated Madison Theatre; just as it was in the 1930s, it makes a great stop before or after seeing a concert at the theater.

The Madison Theatre has come full circle, having started out as a venue for live performances before transitioning into cinema; now remodeled, it operates for live stage shows and short films. With beginnings in 1912, the current Madison Theatre was restored and rebuilt in 1946 after a five-alarm fire, becoming a large, 1,350-seat theater. It became a major attraction for local moviegoers, remaining in operation until the late 1970s. After being purchased by the City of Covington in 1985, another remodeling occurred, and it was reopened in 2001 as an entertainment and banquet facility.

Originally founded by Christy Terzieff and his wife, Mae, Covington Chili operated under their watchful eyes until the 1950s. The Terzieffs sold

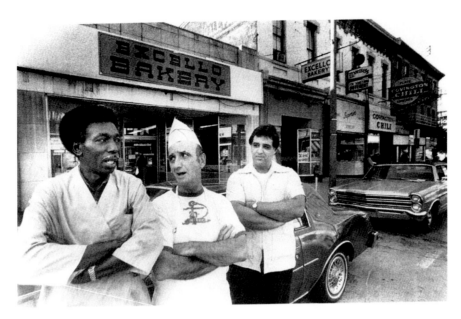

George Stephens (third from left) stands in front of Covington Chili in 1980 with other Madison Avenue business owners. *Courtesy of Kenton County Public Library.*

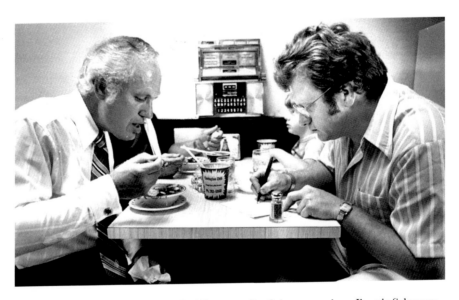

Kentucky governor Julian Carroll, Carl Bowman, Jim Schworer and son Jimmie Schworer dive into dinner at Covington Chili. *Courtesy of the Kenton County Public Library.*

Covington Chili to Tim G. Stephans and his brother, Michael G. Stephans, immigrants from Kastoria, Greece. The Stephans, like many immigrants, Americanized their last name from Stephanopoulos. The Stephans family had a connection to one of Cincinnati's most beloved chili parlors. Tim Stephans married Thomai "Thelma" Ioannou, the niece of Steven Andon, the original founder of Camp Washington Chili and the brother of its current owner, Johnny Ioannou (or Johnny Johnson).

Covington Chili was purchased by George Stamatakos in the 1990s. George expanded the menu to non-chili items and made some minor renovations. Sitting in a narrow storefront, there is room for one row of booths and a long counter with swivel stools facing the steam table and grill. Paintings of food and pictures of chili products adorn the walls. Some of the booths even have their own small jukeboxes, and a large jukebox stands next to the front door but remains silent—it is doubtful if it works. Stamatakos claims that they use 140 pounds of ground beef every day to make the chili. At one point, the Sarakatsannis family of Dixie supplied them their spice mix.

What brings loyal patrons back to this legacy chili parlor is the meatiness and the spicy-savory flavor of the chili. Some describe the flavor as very meaty and somewhat smoky, with a mild spiciness—perhaps the result of a smoked paprika blend. Whatever the spice blend, Covington Chili does something right to keep customers coming back since 1936.

OTHER MADISON AVENUE AND COVINGTON CHILI PARLORS

The Liberty Chili Parlor at 512 Madison was originally opened in 1940 by Macedonian immigrants Pando Golodova, Nicholas Evinoff and Steven Labo. But by 1951, Liberty was owned by Alex Tolevich, who operated the chili parlor into the 1960s. What made the Liberty Chili Parlor and the other nearby chili parlors so successful was their proximity to the Liberty Theatre.

The Liberty Theatre was opened in 1923 on Madison Avenue near Sixth Street by a group of influential Covington businessmen. It was by far the most elegant theater building in northern Kentucky. Designed by famous Cincinnati architect Harry Hake, the Liberty featured 1,500

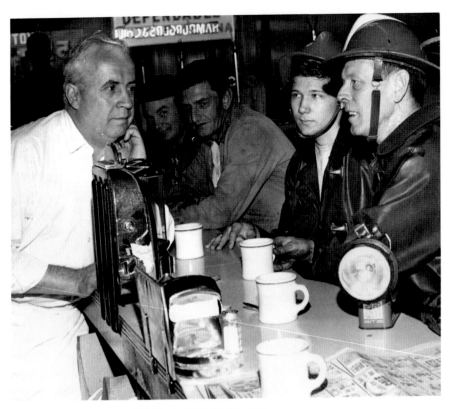

Above: Alex Tolevich, owner of Liberty Chili Parlor, leans behind a countertop jukebox to talk to firefighters Woody Hensley and Jim Carney in 1966. *Courtesy of the Kenton County Public Library.*

Left: James P. Kappas, owner of A1 Chili Parlor at 438 Madison Avenue in Covington, points to the capital of his native Greece. *Courtesy of the Kenton County Public Library.*

blue leather seats on the main floor and balcony, an Italian marble lobby complete with a miniature Statue of Liberty, mahogany ticket booths, a grand marble and brass staircase, a large pipe organ and an expansive mural of New York Harbor on the stage. Catching headlines on many occasions, the Liberty promoted its theater with extravagant giveaways, from free movie passes to free automobiles. The beautiful decorations and ventilated cooling system attracted many customers for nearly five decades. But the theater finally closed in the 1970s, suffering the loss of patrons to suburban multiplexes. The building was demolished to build the Peoples-Liberty Bank.

The Chili Bowl at 438 Madison was owned in 1948 by Risto Vasilovh and then passed down in 1954 to his son, Christoph Vasliov. In 1967, Midtown Chili was operating at 1922 Madison. A Kentucky Chili Parlor at 339 Pike, just off Madison, was owned by Ann Caldwell in 1963 and had moved to 1008 Lee Street in Covington by 1967. The Al Chili Parlor at 438 Madison was owned in the 1960s by James P. Kappas, who also owned the Madison Café & Grill in 1951.

The ABC Chili Parlor at 405 Scott Street was owned in 1951 by William P. and Alex P. Chaldekas. This chili parlor had many connections to other Cincinnati chili families. Will's wife, Bess, was a sister to Albert Jones, who owned and operated a Skyline in downtown Cincinnati. Albert's wife, Carolyn Georgeton, was related to John and Peter Georgeton, who opened the Clifton Skyline until they sold the franchise to Tom Yunger in 2008. Alex Chaldekas was the first customer at the original Skyline in 1949, and his dollar bill hung in that restaurant until it was demolished in 2001.

The city of Covington, Kentucky, is made up of many historic neighborhoods. In addition to the central business district on Madison Avenue, there are other neighborhoods, like Latonia, which was like its own city with its own downtown business district—like a scaled-down version of Madison Avenue. In that business district was the Latonia Theatre. The Latonia was opened in 1931 by Willis Vance at 3628 Decoursey Avenue in what was the old Grand Theatre. Willis operated it until 1939, when he built a brand-new eight-hundred-seat theater around the corner at 15 West Southern Avenue, which he called the Kentucky Theatre. On the opening day, Kentucky moviegoers enjoyed *The Ice Follies of 1939*, starring Joan Crawford and Jimmy Stewart. The Kentucky remained in operation until June 1960, making it one of the area's most successful theaters.

Congressional candidate Gus Sheehan Jr. (left) has coffee with his old friend William Chaldekas, manager of ABC Chili Parlor in the 1950s. *Courtesy of the Kenton County Public Library.*

With the Latonia and Kentucky Theatres came the Latonia Chili Parlor, at 3620 Decoursey Avenue, owned by father and son Samuel and Carl S. Gerros. The Gerros family immigrated to Latonia and, in 1940, were staying with fellow immigrants Nick and William Katsiasnakis. William Katsiasnakis opened the London Chili Parlor at 403 Scott Street in Covington in 1943, next to the ABC Chili Parlor, and relatives Gus and Lee Katsiasnakis opened the Ludlow Chili Parlor at 206 Elm Street in 1940.

Samuel Gerros opened the Latonia Chili Parlor in about 1940, and like the Empress, it was a training ground for other immigrants, many of whom went on to open their own chili parlors. One of the most famous of these was Lazoros Nourtsis, a nephew of Samuel Gerros. Lazoros came to the United States and worked at the Latonia Chili Parlor until opening Price Hill Chili with his son-in-law, Sam Beltsos, in 1964. Latonia Chili Parlor operated until the 1960s.

DAYTON AND BELLEVUE KENTUCKY CHILI PARLORS

Dayton Chili Parlor in Dayton, Kentucky, is the next-oldest continually operating parlor in northern Kentucky. Started in 1939 by immigrants Peter G. Christofield (1892–1964) and Christina Cappos Christofield (1898–1991), its chili has stood the test of time and stayed within the same family for three generations. Peter emigrated from the village of Krokeai in Sparta, Greece, with his parents, George T. (1872–1955) and Angelina Kurlos Christofield (1861–1932), and siblings John (1900–1971), "Tex" (1897–1925) and Lucille. Krokeai was an ancient town south of Sparta between the mountains of Taygetos and Parnon of Laconia, the most southern regional unit of the Peloponnese and mainland Greece. In ancient times, it was known for its green volcanic stone. Their father, George Christofield, ran a shoe repair shop at 2450 Gilbert Avenue in Cincinnati in the 1930s, and their family home was at 1019 Winona Avenue.

Peter Christofield got his training while working at a restaurant called the Orpheum Chili Parlor, run by Albert J. Petry at 905 East McMillen Avenue in Cincinnati, and perhaps this is where he developed his chili recipe. He then operated a restaurant at 1203 Central Avenue in downtown Cincinnati before looking across the river to Dayton, Kentucky.

Dayton Chili opened first at 620 Sixth Avenue. But within a year, the Christofields had moved next door to 624 Sixth Avenue in the old Perry's Candy Store. Peter Christofield had been a World War I veteran back in Greece. With his wife, Christina, he raised three children. His son George began working there as a teenager, taking a short break to serve in the Marine Corps during World War II.

The Dayton Chili Parlor operated under several names over the years, and at one time the Christofields operated two locations. In 1956, Peter's brother, John, opened a chili parlor at 519 Fairfield Avenue in Bellevue, where he and his family lived. In 1976, both his location at 519 Fairfield Avenue and Peter's location in Dayton at 624 Sixth Avenue were called Emerald Chili Parlor. The Dayton location was also called the Eagle Chili Parlor in the 1960s.

Now known as Christofield's Family Restaurant, it has the requisite counter opposite a grill and steam table and also has a mural of a 1950s sock hop. Christofield's also followed the pattern of nestling into a business district near a theater. The Marianne Theatre at 607 Fairfield Avenue in Bellevue opened in 1942 with a 700-seat capacity. With a cry room for

small children, the Marianne remained open until 1992, when the lobby popcorn machine exploded and started a fire. The Dayvue Theatre, a 750-seat theater, opened at 115–177 Sixth Avenue in Dayton. The opening week included the *Road to Zanzibar*, starring Bing Crosby, Dorothy Lamour and Cincinnati-style chili lover Bob Hope. Both theaters operated within blocks of the parlor. Even more importantly, the restaurant sits very near St. Bernard's Catholic Church, so churchgoing business on Saturday evenings made it a good location.

Directly across from Christofield's chili parlor was Ling's Pastry Shop, which Howard and Loretta Ling ran for nearly twenty-five years until closing in 1971. Loretta Ling talked about hearing Christina and Peter arguing in Greek, and she remembered their big dog, Mickey, which could be found patrolling the restaurant in the early days. Peter Christofield's daughter-in-law, Dorothy Christofield, said of the Lings, "We've never had a hamburger bun that tasted as good as Ling's." The Christofields bought the coney and hamburger buns for their parlor from their baker neighbors across the street.

Christofield's, like many other northern Kentucky restaurants, had slot machines. Eating chili and gambling in the same place was something that was definitely different from the Cincinnati chili parlors. A 1950 *Kentucky Times* article reported that several other chili parlors paid slot machine taxes to the commonwealth: ABC Chili Parlor at 430 Scott Street, the Chili Bowl at 438 Madison Avenue, Liberty Chili at 12 Madison Avenue and Ludlow Chili Parlor at 306 Bradley.

Christofield's chili is described as less spicy than most Cincinnati chili parlors. It also is more meaty, has a less fine grind to the meat and is less soupy than other Cincinnati-style chilis. They serve their four-way a bit differently than other chili parlors—with the coarsely chopped onions scattered on top of the cheddar cheese. Some people just want to see their chili "fixins" on top.

In 2009, they decided to change the name from Dayton Chili Parlor to Christofield's Family Restaurant. Now run by George Christofield, the son of the founder, he plans to pass it on to his son, Peter, some day.

To take advantage of the movie crowds, several other chili parlors opened along Fairfield Avenue in Bellevue Kentucky. In 1944, Gus Pappas had a chili parlor at 511 Fairfield Avenue, and Steve Zano operated a parlor at 407 Fairfield Avenue. The Haggis family also operated Bellevue Chili Parlor along Fairfield Avenue, as well as the Haggis Chili Parlor in Latonia.

As Cincinnati-style chili became known in northern Kentucky, several other outlying chili parlors popped up outside Covington, Newport, Dayton

Christofield's Family Restaurant at 642 Fairfield Avenue in Dayton, Kentucky, is one of the oldest continually operating chili parlors in Greater Cincinnati, serving Cincinnati-style chili since 1939. *Photo by author.*

and Bellevue, Kentucky. Angelo's Chili at 2600 Bentos Street was owned by Evangelos Kantos in 1967. A Fort Mitchell Chili Parlor at 2481 Dixie Highway was opened in 1959 and stayed in business until the late 1960s. Tom Pappas operated the Elsemere Chili Parlor in 1941.

Ludlow, Kentucky, west of Covington, had its own Ludlow Chili Parlor, which changed hands and locations over the years. In 1940, it was opened by Lee and Gus Katsiasnakis at 206 Elm Street. It became Charles' Chili in 1957 (oddly enough, owned by a man named David Barnes). Ludlow Chili moved to 306 Bradley Street in 1950 and then to 403 Elm Street in 1951. To follow the common story, the reason there was a Ludlow Chili Parlor at all was to feed moviegoers at the Ludlow Theatre, which was located at 322 Elm Street and operated from the late 1940s into the 1970s.

Today, Cincinnati-style chili parlors have spread as far east as Alexandria, Kentucky, with one of the last remaining Empress Chili locations. Another newcomer to Alexandria is the Old Coney Company, opened by Rick and Sue Neltner in May 2009 in a strip center at 8242 Alexandria Pike. It features wall décor of memorabilia from Campbell County and Bishop Brossart High Schools, as well as historic images of Alexandria and the Old Coney Amusement Park across the Ohio River in Anderson Township. Chili is the main focus of the Neltners' menu, and they serve both mild and hot versions. If you go "all the way," you'll get a chopped hot dog on your five-way. It seems a fitting way to combine a coney and a four-way without the extra carbs of a bun. Seems like health food to me.

While all the northern Kentucky cities are dotted with Skyline and Gold Star Chili chains, it's certainly important to give a nod to the solo chili parlors that paved their way. In an increasingly competitive quick-service restaurant industry, it's amazing that four of the five oldest continually operating Cincinnati-style chili parlor locations are in northern Kentucky. The youngest of these locations has been in existence for seventy-four years and is on the third generation of ownership. It certainly speaks to the loyalty of northern Kentuckians to their hometown favorites chilis.

CAMP WASHINGTON CHILI

October 28 is a big holiday in Greece. It's the day in 1940 that Greek dictator Ioannis Metaxas rejected Benito Mussolini's ultimatum demanding the occupation of Greece. After Metaxas's refusal to submit, Italian Communist forces invaded Greece, but the Hellenic Army counterattacked and forced the Italians to retreat. It was during this war-torn time that Johnny Johnson, the current owner of Camp Washington Chili, grew up near Kastoria, Greece. Johnny's village was set into a hillside, a few miles from the front of the fight against the Communists. Villagers stayed in bomb shelters during the day and went to their homes at night during this terrible time.

For Ioannis D. Iannou and his sister, Thomai Iannou (1929–2009)—or Johnny and Thelma Johnson, as they Americanized their names—this was a perilous upbringing. Lucky for them, their mother's brother, Steve Zizzo Andon (1899–1979), was running a very successful chili parlor in Cincinnati. Steve and business partner Anastas "Fred" N. Zambrun (1897–1977) had opened Camp Washington Chili in 1940 at the corner of Colerain Avenue and Hopple Street in a small red brick building that was once a Kroger grocery. While American teenagers were enjoying sock hops and cokes with friends at soda fountains, the Johnson family were still dealing with the aftereffects of World War II. Johnny and Thelma's parents, Doxates and Maria Andoniou Ioannou, sent their teenaged children to America hoping for a better life.

Steve Andon had left his parents, Zisso and Theodora Andoniou, in 1919 and immigrated to America to escape the turmoil of World War I and the

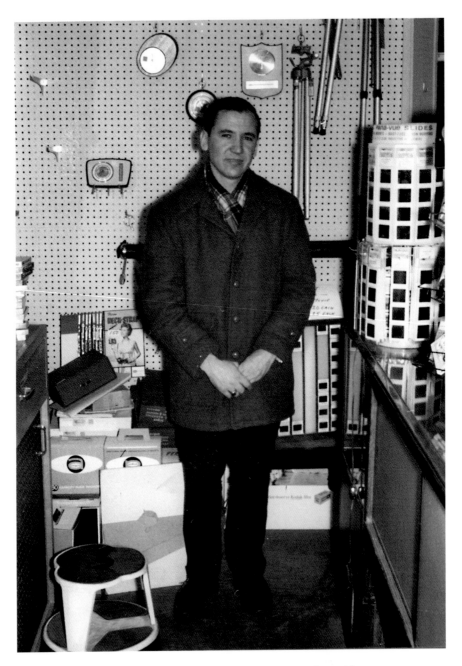

This is a 1951 photo of a young Johnny Johnson the year he emigrated from war-torn Kastoria, Greece. *Courtesy of Maria Johnson Papakirk.*

Balkan Wars. At the time, being a young man, he found work at the Empress Chili Parlor and with other immigrants running restaurants. Steve developed a lifelong friendship with Empress Chili cofounder John Kiradjieff. John was very supportive of his friend opening the chili parlor in Camp Washington and was always a good brain to pick for business ideas.

Johnny and his sister, Thelma, came over in 1951, living with their uncle and aunt, Anna Gregoriou Andon, as well as their cousin, Constance, in Price Hill. Immediately, Johnny started working for his uncle at Camp Washington Chili, learning the business. Because he worked many late nights, he lived in a small apartment with a mattress on the second floor above the chili parlor. Johnny was drafted and served two years, guarding the gold depository at Fort Knox, Kentucky. But aside from that, he has worked for Camp Washington Chili his entire life. Given this commitment to chili-making, it's no small wonder that he's so successful today.

The chili business didn't stop with Johnny Johnson. Johnny's sister, Thelma, married Epthemos "Tim" Stephan (1913–2006) and lived in Oakley on Minot Street with his parents, George (1884–1949) and Sidera Stephan (1888–1968). The Stephans had Americanized their last name from Stephanopoulos. Together they would cross the river and buy Covington Chili, one of the oldest chili parlors in the area, and they ran it for more than forty years. Their son, George, took over management of Covington Chili after they retired.

For a while, Steve operated Camp Washington with Johnny and his business partner Zambrun. But in the 1960s, Zambrun wanted out, so Johnny bought him out of his part of the partnership. That's when Steve Andon brought in his son-in-law, Big John Storgion, Constance's husband. This brought a bit of tension, so in 1977, Johnny bought out Storgion's partnership, and Camp Washington was then all his.

After leaving Camp Washington in 1977, Big John took his money and opened up his own chili parlor, which he called Uncle Steve's Chili, after Steve Andon (his father-in-law, not his uncle). The title was more in jest toward Camp Washington, given that their recipe came from Johnson's Uncle Steve Andon. The location of the first Uncle Steve's Chili was on Colerain Avenue and Galbraith Road near Northgate Mall and the Northgate Showcase Cinemas in an old Provident Bank Building. The Storgions would eventually move to the corner across the street from Camp Washington Chili, shortening the name to U.S. Chili, and another family chili feud began.

Johnny said Camp Washington has never needed to serve alcohol. It was surrounded by bars on Colerain Avenue. At times when it was open late

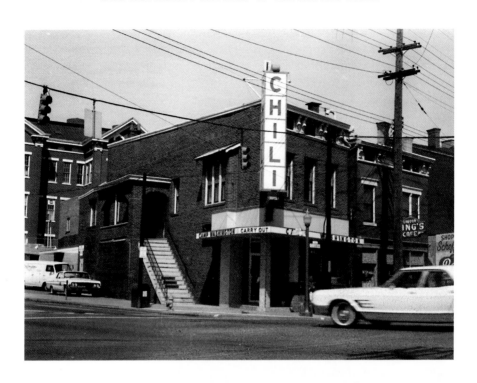

Above: A view of the interior of the original Camp Washington Chili location shows booth-side jukeboxes, which provided fun and an additional revenue source to the chili parlor. *Courtesy of Maria Johnson Papakirk.*

Opposite, top: A view of the original Camp Washington Chili, looking down Colerain Avenue, shows a street filled with bars. *Courtesy of Maria Papakirk Johnson.*

Opposite, bottom: This photo shows the original location of Camp Washington Chili, a former Kroger grocery, looking down Hopple Street. *Courtesy of Maria Johnson Papakirk.*

hours, it served a lot of intoxicated customers. Johnny once saw a man eat eighteen cheese coneys at a sitting in his parlor. Today, being close to the University of Cincinnati and Cincinnati Technical College, something tells me that they serve similar late-night groups with college joviality.

Not only is Johnny Johnson a dedicated worker himself, but he has also always been very good to his workers. One of his cooks, "Goldie," was an immigrant whose parents were both killed in World War II, and he was raised by German stepparents. Goldie could speak German, Yugoslavian, English and Romanian. He had a habit of gambling, but Johnny helped him save $9,000 to visit his stepmother, who was living in Romania, after forty years.

Johnny runs Camp Washington today with his wife, Antigone, and one of his two daughters, Maria Johnson Papakirk. Maria's husband, Jim

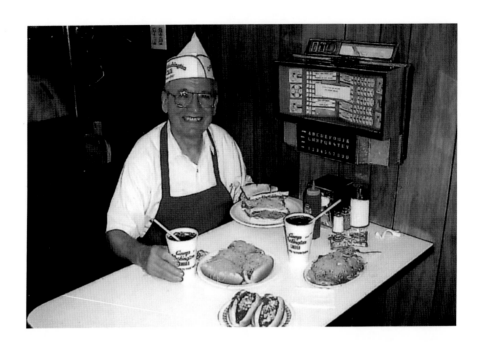

Above: This image shows a rare glimpse into the Camp Washington Chili Commissary. *Courtesy of Maria Papakirk Johnson.*

Opposite, top: Johnny Johnson, owner of Camp Washington Chili, poses in white cap and apron in a booth surrounded by double-deckers, cheese coneys and three-ways. *Courtesy of Maria Papakirk Johnson.*

Opposite, bottom: Goldie takes a break to pose with a waitress. He was a worker at Camp Washington Chili whom Johnny Johnson helped to save enough money to visit his stepmother back in Romania. *Courtesy of Maria Johnson Papakirk.*

Papakirk, now owns the Empress Chili brand. Johnny and Antigone's other daughter lives out of town and works as an architect. The restaurant is open twenty-four hours a day, six days a week (closed Sundays).

The Johnsons grind their beef fresh every day, and only a family member can add the spice blend to the chili. Because their parlor is not USDA-certified, they cannot ship their chili around the country like some of the other local chili parlors. Johnny and Maria both strongly deny the presence of chocolate or cocoa in their recipe but do attest to about eighteen different spices in their blend.

In 2000, a street-widening project forced the chili parlor to leave its original home for a new facility. Johnny's daughter, the architect, helped to

design a modern diner that wouldn't be out of place along Sunset Boulevard in Los Angeles. With a distinct 1950s feel and lots of neon, the new Camp Washington Chili has enough capacity to seat the packed crowds that come into the Cincinnati institution. As a nod to their legacy, they were able to save the old original vertical "Chili" sign and remount it on the new building.

A steady stream of customers flows through Camp Washington Chili at lunch. Men in suits, guys in work clothes, professors and medical workers from neighboring hospitals display the diversity of customers at the parlor. Few are seated without saying hello to owner Johnny Johnson or his daughter, Maria. It's a solo chili parlor that has reached iconic status and achieved national recognition. In 1985, *CBS Morning News* dubbed Camp Washington "the best chili in the country." The *Chicago Tribune* said that Camp Washington Chili is "the best, the most exquisite, and the most unique in Cincinnati, and ergo the greatest in the world." They were featured in print in the March 2000 issue of *National Geographic Magazine*. The parlor was also featured in 2011 on a Travel Channel's *Man v. Food* show. Blues musician Lonnie Mack wrote a song in tribute called "Camp Washington Chili."

In 2000, Camp Washington became the only chili parlor in Greater Cincinnati to be awarded the prestigious James Beard Award as an "American Regional Classic" for its timeless appeal and its commitment to quality food. Started in 1986, the James Beard Foundation is a New York–based national professional nonprofit organization named in honor of James Beard and aimed at promoting the culinary arts by honoring chefs, wine professionals, journalists and cookbook authors at annual awards ceremonies, as well as providing educational scholarships. Johnny proudly displays the award in his restaurant.

Camp Washington is a very old Cincinnati neighborhood that's redefining itself in an eclectic way. Today, it houses the city's slaughterhouses and metal recycling dealers. There used to be a great deal more industry in Camp Washington, but most of it is now gone. The neighborhood sits just on the other side of Interstate 75 from Brighton, another old neighborhood of Cincinnati that now attracts hipsters and artists. Powell Crosley Jr. grew his WLW broadcasting empire and radio manufacturing empire here, and the original corporate headquarters still stands in Camp Washington. One of the oldest Italian Catholic churches, Sacred Heart, holds its spinach ravioli and spaghetti dinner twice a year in the cafeteria of its old elementary school, prepared by the Palazzolo family. The Palazzolos are regular customers at Camp Washington Chili.

Visitors to Camp Washington Chili will also get a rare artistic treat as they park to take care of their chili crave. Displayed on a building behind

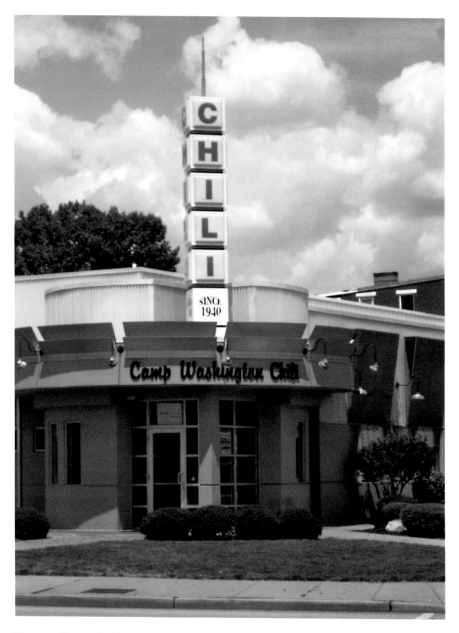

The new Camp Washington Chili location is only twelve years old, but the chili has been a regional classic since 1940. *Photo by author.*

the new Camp Washington Chili Parlor is a large mural. Playing on the name of the neighborhood, the Camp Washington mural team decided to create a "campy" mural. The mural is forty-five feet tall and depicts George Washington's head imposed on a colonial-era woman's body, complete with an elaborate pink and yellow dress and a hand fan. Incorporated into the mural are elements unique to Camp Washington: an image of a cow that escaped from a slaughterhouse and roamed the neighborhood in 2003, a tin man from Jacobs Manufacturing and a gorilla from Schenz Theatrical Supply Inc. The frame of the mural is secured by bolts, painted to represent the industrial nature of the community's business district. And in true Cincinnati fashion, a ring of flying pigs encircle Washington's head. The only thing missing would be a cheese coney in Washington's other hand to give a shout out to the chili parlor that it frames.

Johnny takes the opportunity to visit his hometown of Kastoria, Greece, very regularly. On his last trip in 2012, he stopped in the old Kiradjieff family hardware store and introduced himself as an old friend of Joe Kiradjieff, the current owners' great-great-uncle. Unfortunately, the Kiradjieffs back in Greece know nothing of the chili legacy that their relative started in Cincinnati. But we can thank Johnny for operating and improving the Empress legacy that his uncle, Steve Andon, started before World War II.

MANOFF CHILI AND THE RECIPE BEHIND GOLD STAR

When talking about Cincinnati chili families, there's a name that rarely surfaces, but it is one of the most important in the proliferation of our chili. These particular family members were part of the earliest chili parlors, and it is their spice blend that is the backbone of one of the most well-known chili parlors. What many people don't know is that behind the Gold Star recipe is another less-known Cincinnati family legacy—one that is still strongly involved in the chili business after more than eighty years, just not in Cincinnati but in California as well. This family of chili pioneers is the Petro Manoff family.

Their story begins, as it does for the other Cincinnati chili families, in a small village in the mountains of western Macedonia. The village was then called Mokreni but is now known as Variko, Greece. It was a small village of sixty people and fourteen houses in the former Florina Province. It was an ancient village, first mentioned in Ottoman literature in the 1400s. The area around Mokreni was surrounded by rich farmlands that even today produce beans, corn and wheat. To celebrate this rich agricultural heritage, the village holds an annual bean festival on the Feast of the Assumption of the Blessed Virgin in August.

Petro Manoff and Sophia Gurcheff were married in Mokreni and lived among both of their families there. Mokreni was considered a Macedonian village with ties to Bulgaria and even had a Bulgarian school in the village. Because of this connection and the resistance of its villagers to Turkish control, it was one of the villages burned by the Turks in the Ilden or St.

Elijah's uprising against them in 1903. Petro's parents, Thomas and Jonna Duncheff Manoff, were well off but lost everything due to the uprising. After the Treaty of Bucharest in 1913, when the area was annexed to Greece, many of the Slavic Macedonians moved to Bulgaria or immigrated to America. The village was renamed Variko in 1926.

The Macedonians were in the wrong place at the wrong time. They were at the intersection of fighting between the Greeks and the Turks for control of their land. Before the wars, Petro Thomas Manoff (1882–1972) had worked in a feta cheese factory near his village, but the wars destroyed this prospect of employment. To escape this horrible fighting and build a better life for his family, Petro decided to come to the United States. Petro's brother, Apostol Manoff, followed, traveling with his wife and his son, George, to Cincinnati in the early 1930s.

Petro left his wife, Sophie Gorcheff (1887–1974), and his parents in 1910, the same year his son, Thomas Anastassios Manoff (1910–2006), was born. As most of his fellow countrymen did, he found work with the railroad, cleaning cars. He landed in Canada with another Macedonian from his village, Pando Tasseff (1894–1962). Pando had been a guerrilla, defending the village against Turkish invasion. To escape Macedonia, he had taken the name Jens or James Peterson and secreted to England and then to the United States. Many Macedonians would shorten, change or Americanize their names upon entry to America.

Petro was able to return to Morkeni once during a ten-year hiatus from his wife and son. During that time, he brought back a pair of shoes for his young son that ended up being too big for him. The thought was certainly appreciated, as his wife and young son supported themselves off of the land and had only a donkey for transportation.

Sophia Manoff had two brothers in Morkeni. One, Samuel, was killed in the uprising with the Turks, and his wife was wounded; the other escaped to Argentina. James Peterson (aka Pando Tasseff) returned to Morkeni in 1927 and married Menca Gurcheff (1910–2000), Samuel Gurcheff's daughter and Sophia Manoff's niece, and brought her back to Cincinnati to make their mark in the Cincinnati chili scene. James and Menca Peterson opened the Liberty Chili Parlor in 1938 in the bustling entertainment district of Northside near Knowlton's Corner.

Petro and James eventually worked their way into America and ended up cleaning railroad cars in Cincinnati, becoming connected with the Macedonian immigrant community. By 1920, Petro had saved enough money to bring his wife and son over to America. So Sophia Manoff, ten-

year-old Tom (or "Tassi") Manoff and a friend, Marie Petroff, made the long voyage to America on the steamship TSS *Themistocles*, landing at New York's Ellis Island. Everything the Manoff family owned was in a three- by four-foot trunk, which the Manoff family still has. While in New York City, little Tom Manoff found a ten-dollar bill on the floor of a train station. Never having seen paper money, he nonetheless knew it was important and gave it to his mother, who used it to buy train tickets to Cincinnati. Upon arrival, they met up with their husbands, Petro and Samuel Petroff, who lived on East Third Street in downtown Cincinnati.

Mary Manoff was born to Petro and Sophia in 1924 at the East Third Street homestead. She would marry another Macedonian, Louis Ellcoff (1920–1983), in 1946. Using her brother Thomas Manoff's chili recipe, Mary and Louis Ellcoff would open and run the West End Chili Parlor in 1944 at 701 West Court Street in Cincinnati's densely packed West End neighborhood. From the 1960s to the 1970s, the couple owned Mary Lou Grill on Colerain Avenue, still serving the Cincinnati chili recipe borrowed from her brother. Then, Louis, a Macedonian, partnered with a German woman to operate an Italian restaurant called Mario's Wine Cellar. Finally, the couple ended their food career after owning the Glenmore Bakery on Glenmore Avenue.

The Manoffs settled into the Macedonian immigrant community in Cincinnati. After 1922, an immigrant husband's U.S. naturalization did not automatically make his wife a citizen. Women had received the right to vote in 1920, so it became an immigrant woman's duty to achieve naturalization on her own. Sophia Manoff, known as "Baba Feke" to her family, loved her country and her Macedonian heritage. Sophia had gone up to the fourth grade in the Bulgarian school in Mokreni and could read and write Bulgarian as well as Macedonian. She never became a U.S. citizen, though, and lived out the rest of her life as a Macedonian. Sophia was a dedicated member of the MPO Bistritsa, the local chapter of the Macedonian Patriotic Organization, which sent her to the yearly national conventions. The Cincinnati chapter was named after the Bistritsa River, which flowed through Bulgaria and Macedonia. The purpose of the organization was to help free Macedonia and make it an independent state like Greece, Bulgaria and Serbia, but the area eventually became part of Greece. Sophia Manoff instilled this love of Macedonian culture into her children by reading to them Macedonian children's books to help teach them the language.

The younger Manoff children also attended Macedonian school three times a week with other children of Macedonian immigrants to learn how

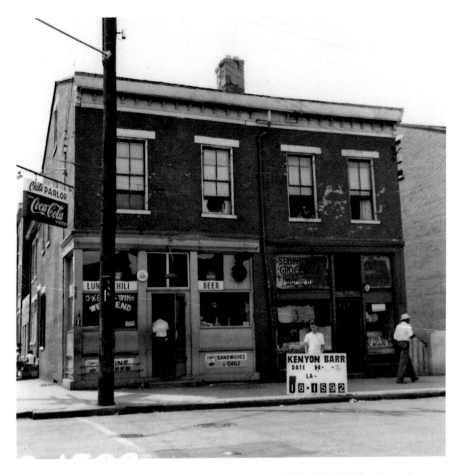

A photo of Mary and Louis Ellcoff's West End Chili Parlor in the 1950s before the entire neighborhood was torn down to make way for Interstate 75. It is now known as Queensgate, an area with mostly industrial facilities. *Courtesy of the Cincinnati Historical Society Library.*

to read and write Macedonian. The Macedonian word that many of them would come to know was "чиле," or chili. The group rented a room at the Guilford school on Fourth Street in downtown Cincinnati in the 1930s, and they were taught by Sotir Phillips and Evan Petroff.

Petro moved the family to Newport, Kentucky, to 935 Washington Street. It was a two-family house; the Manoffs lived upstairs, and friends Samuel and Marie Petroff lived on the first floor. Flora (Manoff) Haggis was born at this house in 1926. Flora married Samuel "Pete" Haggis (1926–1998) in 1948. He was the son of Pete and Cleopatra Haggis, Greek immigrants and owners of

Macedonian schoolchildren pose in 1935 at the Guilford School on Fourth Street in Cincinnati with their teachers Sotir Phillips and Evan Petroff. *Left row along blackboard, left to right*: Boris and Christina Tarpoff, Pete Ellcoff, Mick Tarpoff, unknown, Louis Ellcoff, Benny Stevens and Helen Petroff. *Center row, left to right*: unknown, Bill Manoff, Carl Tarpoff, Phillip Chachoff, Michael Chachoff, Florence Mitroff, Mary Manoff and Slafka Tarpoff. *Third row, left to right*: Walter Mitroff, Steve Tarpoff, Flora Manoff, Anna Petroff and John Petroff. *Courtesy of Todd Manoff.*

Bellevue Chili Parlor in Kentucky. Pete Haggis was doorman at the Terrace Hilton Hotel for many years and, with Flora, owned a Baskin-Robbins Ice Cream shop on Sixth Street and a Creamy Whip on Glenway Avenue.

Vasil (or "Bill") Manoff was born in 1927, and he married Helen Mallios in 1951, also of Macedonian descent. Two other children, Alex and George Manoff, died as infants. Bill Manoff (1927–2007) served in the U.S. Army and then joined Ford Motor, where he worked until his retirement. He was the only Manoff family member who was not involved in the chili business.

Petro and his friend, Samuel Petroff, owned the Bank Café at Twelfth and Vine Streets in Cincinnati for a few years. This would be the first in a long list of restaurant ventures for Petro. A fact unknown to chili historians is that Petro Manoff was one of two other original partners in 1929 with Nicholas

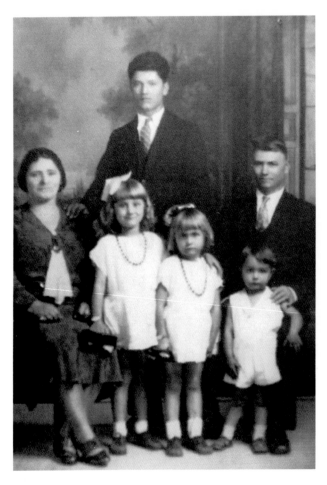

The Manoffs were a true chili family. Seated is Sophie, who worked at Strand and Hamburger Heaven. Tom Jr., standing, worked at Strand and ran Tip Top, Hamburger Heaven and Rancho Burger. Mary Manoff and her husband operated Cheviot Chili. Flora Manoff married Pete Haggis, whose family ran chili parlors in Kentucky and Cincinnati. Bill was the only Manoff not involved in the chili business. Petro Manoff invented the chili recipe that would become Gold Star Chili. *Courtesy of Todd Manoff.*

Sarakatsannis in Dixie Chili on Monmouth Street. After only a short time, a disagreement caused Petro Manoff to leave Dixie. Petro next operated the Peebles Café, a saloon and bar with two other partners on Gilbert Avenue in Walnut Hills. This was near Peebles Corner, a bustling area at the intersection of Gilbert and McMillen, anchored by the Peebles Department Store. This corner was the intersection of six streetcar lines, making it the busiest district outside of downtown. It also supported two theaters. The Orpheum Theater at 941 East McMillen was built in 1909 and became a popular vaudeville and picture theater. In 1918, the Orpheum opened a second screen within the theater and used two Wurlitzer pipe organs until the building was razed in 1952. The Orpheum Chili Parlor at 905 East McMillen was opened in the early 1940s by Peter Christofield of the Dayton

Chili Parlor family and Albert J. Petry to service moviegoers. Then, in 1931, RKO Paramount Theatre opened at Peebles Corner. Petro Manoff certainly knew how to choose a good location for a restaurant.

The Peebles Café served chicken and near beer because it didn't have a liquor license. The partners operated this restaurant for only three months and then closed it. The other two partners would not give Petro back the equipment he had bought for them. So, one night, Petro and Tom went down to the restaurant at midnight and collected the equipment (for which he still had the receipts). The paper the next day detailed the "robbery" that had occurred.

Next, Petro and Thomas Manoff opened the Strand Chili Parlor in about 1931 at 843 Monmouth Street in Newport, Kentucky, just one block south of the Dixie Chili Parlor. It would truly be a Manoff family business. Petro's wife, Sophie, was a cook. Their son, Thomas, and his wife, Dorothy, and daughter, Flora Manoff, were all involved in the business. They were open twenty-four hours, with two twelve-hour shifts run by Petro and Thomas. Strand had two slot machines from which Petro and Tom made about seven dollars per week from the percentage of the slot revenue. Because it was during the Great Depression, the Manoffs would accept whatever amount customers could pay to eat. Even though people had no money for food, they would take a chance on the slots.

Only a few blocks south of the chili parlor on Monmouth Street, one can see today in the Newport Gambling Museum the type of nickel slot machine (supplied by companies like the Mills Novelty Company in Illinois) that existed in all these Newport restaurants. Before Las Vegas was established, Newport, Kentucky, had the largest number of gambling clubs in the United States. Both Dixie Chili and Strand Chili Parlors were in the heart of Newport's "Sin City"—known for illegal gambling and gangster-run establishments into the 1950s. Newport had it all—gambling, prostitution, bootleg liquor and relaxed law enforcement.

Being in the heart of this action, especially on the night shift, made the Strand a somewhat dangerous place during this gambling heyday. One night in 1935, a group came in and robbed the Strand Chili Parlor. The men hit Petro over the head with a grinder and stole his money. The entire episode was detailed in the *Kentucky Post* the next day.

Strand Chili Parlor placed an advertisement in the 1931 Newport High School yearbook. This was the high school from which Mary, Flora and Bill Manoff would graduate. This makes the Manoffs' Strand Chili Parlor the first known Cincinnati-style chili parlor to advertise. The Manoff family

marketing prowess would carry them through a number of successful chili parlors and restaurants.

Following the formula that the Kiradjieffs had set, the Manoffs' Strand Chili Parlor was directly across the street from a theater, the Strand at 827 Monmouth Street. Opening in 1916, Newport's Strand was the first northern Kentucky movie house to feature "talkies." On May 14, 1929, the *Kentucky Post* announced that a new talkie, *In Old Arizona*, would be engaged for the entire week. Sound cinema being new to Americans, the *Post* tried to describe the film to its readers on May 14, 1929, by saying, "The audience hears the players talk as soon as they are seen to act."

The Strand, owned by Gus Phillips, was renovated in August 1931, just before the Manoffs opened their chili parlor, and it was run until the mid-1940s, making it one of Newport's most successful theaters. Petro's youngest son, Bill, was an usher at the theater in 1946. For Newport's mostly working class, a Saturday movie at the Hippodrome or the Strand on Monmouth Street, followed by a coney, a coffee or a waffle afterward, was a weekly break to a tough week.

Thomas Manoff Jr. was born to Thomas and Dorothy Manoff in 1937 across the street from the Strand Chili Parlor in an apartment above a meat market. Thomas Sr. had to wait until after lunch hour rush to see his newborn son. When Thomas Jr. was a toddler, his father would make him lift weights behind the Strand Chili Parlor near the outhouse to build his strength.

Even though Petro had experience with the Dixie Chili recipe, which was a version of Empress's, his son, Thomas, decided to work for the masters at Empress Chili on Fifth and Vine in 1938. He was a mustard boy in the "coney island assembly line." Having a name that ended in "eff" or "off," all he had to do was ask for a job, and there was an apron waiting. The assembly line consisted of one guy who would put a dozen buns on a rack, adding hot dogs. Tom would paint the mustard on the buns, and someone else would ladle chili over the dogs.

Tom Jr. confirmed that John Kiradjieff mixed the spices at home, bringing them in small bags to the chili parlor so that no one could steal the secret blend. However, in the Manoff family, there is a story that Thomas secreted some of the Empress spice blend to a chemist. With the technology of gas chromatography, the chemist was able to tell Manoff what ingredients were in the spice blend but not the exact ratio of spices. So, Manoff was left to his own devices to create a blend of the seventeen secret spices into his own Manoff chili blend, which was modified and perfected over many years.

Meanwhile, Sophie Manoff's niece and her husband were preparing for their chili parlor. After working for the railroad at Union Terminal, James and Menca Peterson opened the Liberty Chili Parlor in Northside in 1938

in Cincinnati. The Liberty Theatre had been one of the earliest theaters, opening in 1929 but closing only a few years later. After selling the Liberty, the Petersons operated Cheviot Chili Parlor at 3626 Harrison Avenue. Then, from 1945 to 1953, they operated the White Star Restaurant at Ninth and Vine Streets. Finally, from 1953 until they retired in 1960, they operated the Cheviot Chili Parlor on Glenmore Avenue.

In 1936, first cousin George Manoff, with his wife, Mary, started the Oakley Chili Parlor in an eastern suburb of Cincinnati at 3123 Madison Avenue. They only operated for a few years before selling the business to Norman Phillip Bazoff, who would shortly open the Park Chili Parlor in Northside.

Opening a chili parlor during the Depression was challenging, but then came World War II. The Manoffs were then living at 314 East Fourth Street in Newport. In 1946, the Manoffs sold the Strand Chili Parlor to Thomas Sarakatsannis, the brother of Nicholas Sarakatsannis, who had founded Dixie Chili. The Sarakatsannises renamed the parlor Crystal Chili Parlor, after a restaurant they had had for a few years in Cincinnati.

The sale of the Strand Chili Parlor ended the Manoffs' Kentucky chili legacy. Tom and his brother-in-law, Frank Bedell (his wife Dorothy's sister's husband), both got jobs at Wright Aeronautical toward the end of World War II to avoid being drafted. Tom was an engine inspector, and Frank had a desk job there. Wright Aero was immortalized in a mosaic mural by artist Winold Reiss at the Union Terminal, where Thomas's father, Petro, had worked for several years cleaning railroad cars.

But their chili empire wasn't over yet. After only a year or so as mechanics, the war ended, and their minds again turned to the food business, where they could be their own bosses. Thomas and Dorothy Manoff sold their home in Highland Heights, Kentucky, and moved in with Dorothy's grandfather, Grandpa Kiefer, to save money to open a new restaurant. Taking advantage of the new hamburger craze sweeping America, Tom Manoff and Frank Bedell opened Tip Top Hamburger Shop at 40002 Glenway Avenue in 1946, three years before Nicholas Lambrinides opened the first Skyline Chili at Glenway and Warsaw Avenues. They named it Tip Top because it was at the top of Price Hill. In addition to their juicy hamburgers, Manoff and Bedell served the Manoff secret recipe of Cincinnati chili at Tip Top.

In 1948, Barlett and Zier bought the Tip Top from the Manoffs and opened a men's clothing store there. This gave Evon Vulcheff—who ran his Glenway Chili Parlor in 1947 only a few doors down, at 4010 Glenway Avenue—the market on chili in Price Hill. Vulcheff then sold it, and it became Hilltop Grille in 1958.

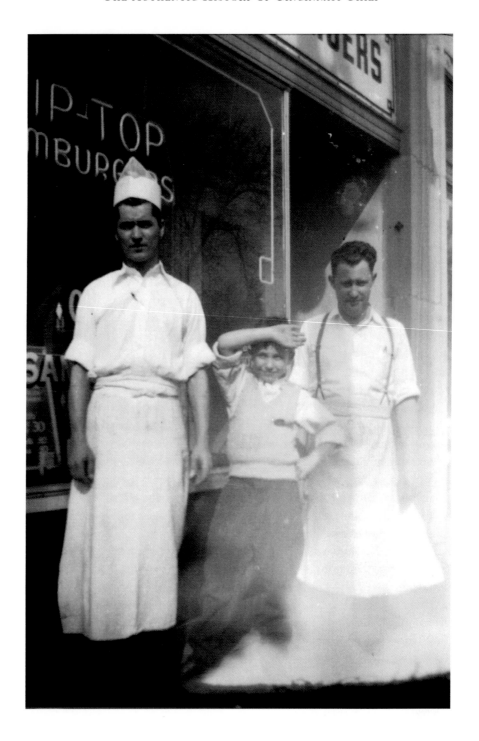

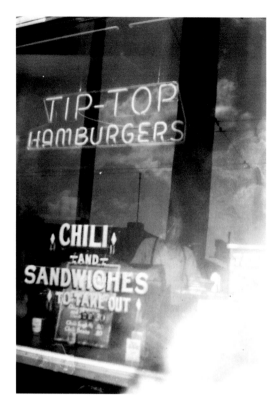

Opposite: This 1946 photo shows Thomas Manoff, his son, Thomas Jr., and Frank Bedell in front of Tip Top Hamburgers at 4002 Glenway Avenue. *Courtesy of Todd Manoff.*

Left: The sign of Tip Top Hamburgers read, "Chili and Sandwiches to take out." *Courtesy of Todd Manoff.*

Below: This 1946 photo shows Thomas Manoff and brother-in-law Arthur Marsh behind the counter inside the Tip Top Hamburger shop. *Courtesy of Todd Manoff.*

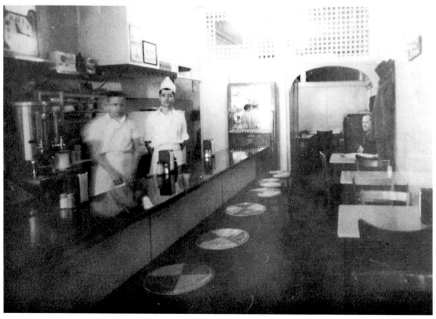

After selling Tip Top, Thomas Manoff opened a new restaurant he called Hamburger Heaven at 2240 Beechmont Avenue. This was a small burger shop in the front of an old 1920s bungalow owned by Dale R. Bogart. One side was Hamburger Heaven, and the other side was Bogart's wife's real estate office. But the real kicker was that across from the restaurant was the elegant Elstun Theatre, run by Elstun Dodge and his mother, Rose. Opening in 1937, the Elstun was a one-screen theater that showed first-run movies and operated until 1962. On a Saturday in the 1950s, a kid could pay fifteen cents to enter and ten cents for a bucket of popcorn and spend the day watching serials, cowboy movies or other great 1950s movies like *The Blob*.

This prime location gave the Manoffs a good customer base for their restaurant. Thomas Manoff Jr. remembered a Sunday manager who would eat at Hamburger Heaven and gave them free movie passes. At the time, the Manoffs lived in an apartment above the Western Auto Parts Store across the street on Beechmont Avenue.

When the Manoffs ran Hamburger Heaven, they sold more hamburgers than chili. Thomas Manoff Jr. said, "Chili country at that time was limited to downtown Cincinnati and the West Side." The East Side had not yet become accustomed to Cincinnati chili and had not developed the crave.

Hamburger Heaven had twelve stools around a J-shaped counter and three booths. Grandpa Kiefer, a carpenter by trade, had built these booths for the Manoffs. Initially, the Manoffs had a large wall-mounted jukebox by the front door, but they replaced it with a much smaller counter-mounted jukebox by the register. You can almost imagine hearing a Platters song at Hamburger Heaven while waiting for your chili. A hand-lettered marquee above the steam table advertised chili spaghetti for forty cents, the same price as a hamburger platter; chili with beans for twenty-five cents; cube steak sandwiches; and French fries for fifteen cents. They offered breakfast all day and served Pepsi products. Another sign proclaimed that the chili was made fresh daily and government inspected.

Opposite, top: The Elstun Theatre on the north side of Beechmont Avenue, across from Hamburger Heaven. The film being shown that night was *Tomahawk*, released in 1951. *Courtesy of the Anderson Township Historical Society.*

Opposite, bottom: The exterior of Hamburger Heaven shows the modest diner next to the Bogarts' real estate agency on Beechmont Avenue in Mount Washington. *Courtesy of Todd Manoff.*

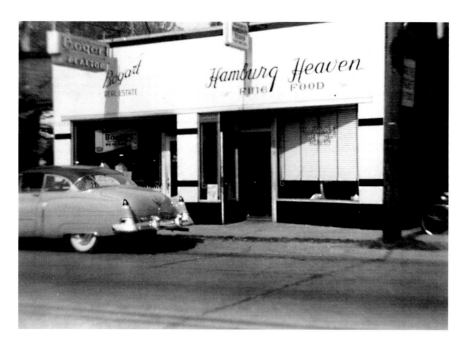

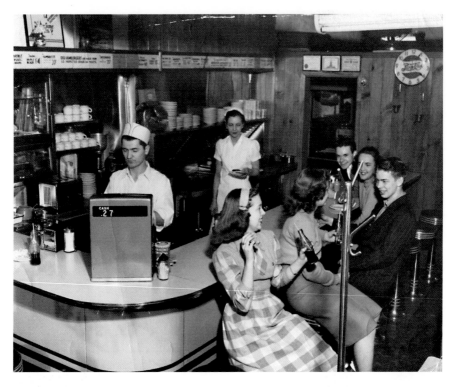

Above: A posed photo inside Hamburger Heaven for a high school yearbook ad shows Thomas Manoff behind the counter and his wife, Dorothy, serving a group of high school students. Sitting on the second stool is Jeanette Manoff, their daughter. *Courtesy of Todd Manoff.*

Opposite, top: Dorothy and Thomas Manoff Sr. packaging chili in January 1955 at their chili plant on Kellogg Avenue. *Courtesy of Todd Manoff.*

Opposite, bottom: This is the lid for "Manoff's Famous Empress Brand Frozen Chili." Tom Kiradjieff, owner of Empress Chili, made them remove "Empress" from the name. *Courtesy of Todd Manoff.*

In 1955, Thomas and Dorothy Manoff opened Manoff's Frozen Chili Plant on Kellogg Avenue at the bottom of the hill from Mount Washington. At the plant, they cooked, packaged and froze Manoff's chili in reheatable containers and sold them at local markets, delis and pony kegs, as well as to Kroger's and Albers supermarkets. The chili was packaged in aluminum trays with a heavy board lid and was available as chili con carne, straight or with beans, and there was also chili with spaghetti. The first problem they encountered was their choice of brand name. Their first label read,

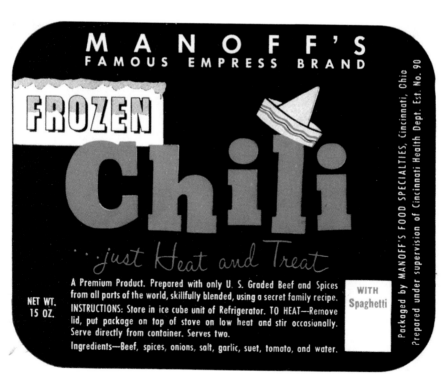

"Manoff's Famous Empress Brand Frozen Chili." By the mid-1950s, the Empress Chili brand was well known in Cincinnati, but Tom Kiradjieff wouldn't have the Manoffs profit from their coattails. So the "Empress Brand" part was removed from the Manoff chili label.

The next challenge that the Manoffs faced was that their current business permit only allowed them to sell direct to customers, not to other businesses for resale. So, a lot of their packaged chili was stamped in the market by the health department not to be sold and disposed. After getting the proper permit for resale, another challenge faced them. The freezing of chili took too long in the freezers of the 1950s. They just couldn't freeze the chili fast enough to keep up with the orders. Thomas investigated the investment needed to purchase the subzero chillers to keep up with their orders. After learning of the huge investment that this would take, they decided to close the plant. Years later, Thomas said that he wished he had just sold the dry spices. That, he believed, was where the money was.

The Manoffs had always dreamed of going to California. Tom and Dorothy's daughter, Jeanette, was the first to say goodbye to Cincinnati and hello to the sun. She left for San Francisco, California, in 1952. Tom Sr. had also always wanted to move to California, and in 1955, they sold Hamburger Heaven to his brother-in-law, Joe Marsh, and followed their daughter, moving to Santa Cruz in 1956, sight unseen.

Joe and Lillian Marsh continued serving three-way chili for forty-five cents, chili burgers for sixty-five cents and coney islands for fifteen cents, but they changed their loyalties from Pepsi to Coca-Cola products. The Marshes also added another Cincinnati favorite to their menu in 1963: the German delicacy goetta and eggs.

With the money from selling Hamburger Heaven, Thomas and Dorothy purchased a restaurant at 243 Murphy Avenue in Sunnyvale, California. Originally called Hoeflers, it was a large place that sat 165. They changed the name to Manoff's and operated until late 1958. After that, the Manoffs took a few months to scout around for a new location for their next restaurant venture. They also took time to visit their family in Cincinnati. Knowing how the food business works, and knowing that the only way for them to visit was to work, they threw in a helping hand and worked at Hamburger Heaven with Joe and Lillian Marsh.

In May 1959, the Manoffs purchased a small place on the corner of Water and River Streets in Santa Cruz, California, for $12,000. It was a tiny prefab building with a single U-shaped counter; it was called Chip's Drive-In and was operated by A.E. Chipman. The Manoffs remodeled, removing

half of the building and adding a dining room. They named it Manoff's Rancho Burger, opened it in June 1959 and gave it a western theme with wagon wheels, spurs and branding irons on the walls. Customers resisted any remodeling from this original theme because it reminded them of a simpler time. Burgers were sold for fifty cents, and they went through twelve homemade pies a day. Their pies were advertised by a sign above the register that read, "Homemade pies—Not like Grandma made, like she thought she made." They served three-way chili for seventy-five cents, chili with beans and chili straight. They called chili spaghetti "chili mac."

In 1966, the City of Santa Cruz swiped fifteen feet off the Manoffs' property to widen Water Street. Since the building sat right on the corner, it had to be demolished. But the Manoffs rebuilt a new building in the rear corner of the property and reopened in 1967. Thomas Sr. retired in 1972, but Thomas Jr. and his wife, Kathleen, continued running Manoff's for more than forty years until 2001, when they retired. Thomas and Kathleen's son, Todd Manoff, worked for them until 1994.

The hardy Manoffs survived the storms of 1982, the 1989 San Francisco Earthquake, the health food craze, increased fast-food competition and shortage of employees. They cooked without electricity and used paper plates the day after the San Lorenzo River flooded upriver near Felton in 1982, threatening downtown Santa Cruz and knocking out power and a water main. After the 1989 earthquake, which left Pacific Avenue in ruins, they used only the gas stove because the electricity was out. But through it all, Cincinnati chili was always a big part of the menu at all the Manoff locations. About 30 percent of their sales were Cincinnati chili, but it was the burgers that kept them going. Tom Manoff Jr. figured that he served about 1.5 million since he began at age fourteen.

A chili sign that hung at Hamburger Heaven and Manoff's Rancho Burger for forty years is probably the earliest advertisement speaking to the "crave" of Cincinnati chili. A couple dressed in top hat and tails and formal dress are on their knees, pleading, "Tell us Manoff. Tell us the secret of your chili con carne." Manoff smiles proudly. Why should he reveal the secret of the finest chili this side of heaven? "Truly, this is no ordinary chili...Men and women who have tasted his chili proclaim: 'It's Manoff's premier dish.' We warn you in advance—neither kind words nor harsh fair means or foul will pry loose Manoff's recipe. You'll not be able to duplicate it at home...Once you taste 'IT' we have you...You'll become a regular visitor at Manoff's... It's a scurvy trick...but you'll bless us for it!" Now that's some great early chili advertising.

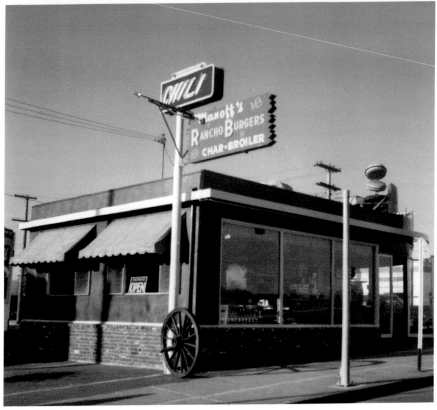

Much like the closing day at the original Skyline Chili Parlor, the last day in 2001 at Manoff's Rancho Burger was an emotional day. Longtime customers presented the Manoffs with cards, candy, balloons and flowers. The *Sentinel* reported that "Manoff's was a place where buttermilk and root beer floats were still on the menu, and former Midwesterners could get a good bowl of Cincinnati chili, which contains 17 spices and takes six hours to make." The Manoffs sold to Mike Mitchell, who opened Mike's Soul Food at the location. It was important to the Manoffs that it remain an owner-operated business.

Joe Marsh operated Hamburger Heaven for ten years after he bought from Thomas and Dorothy Manoff. But he, too, couldn't resist the urge to move west and sold Hamburger Heaven in 1965 to four brothers from Jordan eager to start their stake in the American dream. Marsh moved to California with money in his pocket and opened a Foster Freeze, a soft-serve ice cream walk-up window that served burgers, but he never served the Cincinnati chili that his brother-in-law, Thomas Manoff Sr., had perfected. The four Jordanian brothers whom Marsh sold to were Fahid, Basheer, Beshara and Fahhad Daoud, who used the Manoff Cincinnati chili recipe to start their Gold Star Chili empire, but that's another story.

In 1967, Frank and Stella (Marsh) Bedell, who had operated Tip Top Hamburgers with Thomas and Dorothy Manoff, sold their grocery and deli in Cheviot and came out to California to follow the rest of their family. Tom Sr. had been sending them pictures of their Rancho Burger, proclaiming its success. So, they opened up a second Rancho Burger. But Frank Bedell died suddenly of a heart attack. His widow, Stella, was devastated and closed the Rancho Burger. Her younger brother, Art Marsh, who had worked at Tip Top Hamburgers, came out and reopened the second Rancho Burger, renaming it the Silver Spur. He continued to serve Cincinnati-style three-ways and chili.

Opposite, top: This is the chili sign that hung in Manoff's Hamburger Heaven in Cincinnati in 1947 and then at Manoff's Rancho Burger in Santa Cruz, California, for forty years. This is the earliest known Cincinnati chili advertising speaking to the "crave." *Courtesy of Todd Manoff.*

Opposite, bottom: The original 1959 Manoff's Rancho Burger, where they continued to serve their secret recipe of Cincinnati chili. Notice the rotating fiberglass hamburgers on the roof. *Courtesy of Todd Manoff.*

About five years ago, Tom Manoff Jr. came to Cincinnati for his fifty-year high school reunion and stopped by the original Gold Star Chili location on Beechmont Avenue. He put a card in the suggestion box with his number saying that he was a Manoff and that his grandfather created the recipe for their chili. He received a warm phone call from the then CEO of Gold Star, who was very interested to hear the Manoff family chili story. Tom Manoff Jr. said that Gold Star's chili tastes pretty much like his father's chili, only a bit more watered down.

The Manoffs still make chili, and when they do, it's an extended family cookoff. They also support their local schools, providing the knowledge and the manpower for chili cookoff fundraisers. Todd Manoff, great-grandson of Petro Manoff, and his wife, Joanna, still sell the original mix of seventeen spices from the original recipe developed by "Great Papa Manoff" back in the 1930s at the Strand Chili Parlor in Newport, Kentucky. This was the same fine chili that Thomas Manoff Sr. served at Tip Top and Hamburger Heaven and then later in Santa Cruz, California, where it was popular for forty years at Manoff's Rancho Burger.

Although they're still not willing to reveal the exact spices in the mix, their recipe gives us a view of one of the oldest Cincinnati chili recipes in existence. The spice mix comes with about a cup of dry spices, three dried red chili peppers and a cheesecloth bag of other spices, including a bay leaf, that are removed from the final chili. The following is their recipe, which can be ordered online at joannamanoff@aol.com:

MANOFF'S FAMOUS CINCINNATI CHILI

The spice package with onions, a can of tomato puree and 4¼ pounds of ground beef will make 1 gallon of Manoff's Cincinnati chili.

Add water to 4 oz. of dehyrdrated onions and let soak. Meanwhile, boil a large pot of water. Place ½ tablespoon of shortening or lard in separate 1-gallon pot, and heat until melted. Add onions and stir as needed until browned.

Add package of spices and 15-oz. can of tomato puree to ground meat and mix thoroughly. Add boiling water to meat and spice mixture until it fills 1-gallon pot. Add spice bag and dried chili peppers. Cover and let simmer, stirring ever so often.

Cook approximately 4 hours, stirring occasionally. Add more water as it boils down. Sprinkle in cracker meal or finely crushed saltines to thicken before serving. Mix well as you dish out to retain even consistency. This chili freezes well!

Serve in the following ways:

Chili straight: dish direct into bowl and serve.
Chili beans: dish chili over cooked pinto beans.
Three-Way Chili: cook up spaghetti with a little heated tomato puree. Place
spaghetti on dish and ladle chili over top. Add grated cheddar cheese.
Four-Way Chili: add fresh chopped onions.
Five-Way Chili: add pinto beans.
Put chili on burgers or hot dogs.

The four-generation chili legacy of the Manoff family is a lesson in perseverance and customer service. Even though they never expanded through franchising, the Manoffs learned the formula that many restaurateurs never learn: the formula of what makes a truly successful business and what makes a delicious Cincinnati-style chili that creates the crave.

GOLD STAR CHILI

The Gold Star Chili story is much different from the other chili parlors. For one, the family brothers were the last to the chili game. The family behind the chili also have a different origin than the other Cincinnati chili families. The Daoud family history begins in a small village in Jordan called Fuheis, near the border of Israel and Syria in the Jordanian goverate of Balqa. Fuheis is only about twelve miles north of Amman, Jordan's capital. The village is the only overtly Christian settlement in Jordan, with 60 percent of of the population being Greek Orthodox. Although the population is roughly thirteen thousand, it doubles in the summer when those who immigrated to the United States and Europe come back to spend their summer vacations. In the entire nation of Jordan, Christians are a minority. They amount to only 10 percent of a population that is largely an observant, conservative Muslim nation. Christians are an integral part of society, though, and have played a vital role in the development and prosperity of the country. Jordan has long touted itself as a country of religious freedom, and these Arabic Christians in Fuheis predate the Muslims.

The Daouds described Fuheis as a very beautiful, hilly region, largely dependent on farming, cattle and sheep. It's also well known for its traditional customs, like the dancing of the dabkeh, an energetic line dance performed at marriages and other joyous celebrations. Although the religious backgrounds harken back to Greece, the food, customs and clothing are definitely Arabic. Although originally very agrarian, most of the inhabitants of Fuheis today are well educated and either work in government positions or run their own

businesses. Because new land is scarce and the area is very desirable for Arab Christians living in Amman, property, when it becomes available, is very expensive. There is still an olive farming economy and a cement industry, both of which employ mostly non-Jordanians. At Christmastime ("Eid al-Miilad" in Arabic), Fuheis has the largest Christmas tree in Jordan in its town square and one of the largest Christmas bazzars in the Middle East. Rooftop cafés dot the picturesque landscape.

The area is very near the ancient cities of the Bible. The city of Petra is a short trip away, as is the Dead Sea. A popular trip when visiting Fuheis is a stop to dip in the Dead Sea and have a mud bath.

The Daoud family were tobacco farmers for several generations in Jordan. Shakir Daoud, who I'll call the grandfather of Gold Star Chili, valued higher education a great deal. The region of Fuheis in the 1950s was a very modest agricultural area, so to obtain a higher education meant leaving Jordan for America. Shakir Daoud had a dream that each of his ten siblings would have this opportunity. But to send them all out on their own into the strange American world was a perilous decision.

Luckily for them, Shakir's brother had left Jordan to pursue a better life in America in the 1930s. The family had not heard from him in more than twenty years and assumed he was dead. Then the Daoud family received an unexpected letter from this uncle. He sent love home and told them that he was living in a city in America called Cincinnati. He was working in a variety of jobs there and doing very well. Shakir thought that it was a good time for his sons to begin their journey. This gave the four Daoud brothers—Basheer, Beshara, Fahhad and Fahid—the American opportunity that their father had imagined.

The first brothers to leave Jordan were Basheer and Fahhad, who left in 1951. Fahid, the youngest of the Gold Star founding brothers, recalled these farewell gatherings when people left Fuheis for America. People cried and wailed as at a funeral, and they believed that those leaving would never be seen again. Fahid followed his brothers and came to the United States in 1957 when he was twenty years old. Fahid also recalled the trip over as being very treacherous, and some storms threw the ship in such turmoil that you wished you were dead. The sea sickness that people had to endure was unbelievable. But when they saw the first sight of the Statue of Liberty, he relaxed, knowing that he had finally made it to New York City to begin his exciting new life.

Fahid took a taxi to the Greyhound bus station in New York City upon landing, but he had no money. So, to fund his trip to Cincinnati to meet his brothers,

he had to pawn a used watch he had brought with him. When he arrived in Cincinnati, his brothers were getting ready to go to a New Year's Eve party. So Fahid decided to go with them, even though he was tired and overwhelmed from the trip. After a few drinks, he thought of his parents and immediately become homesick. He started crying uncontrollable and ruined his brothers' evening because they were forced to take him home early from the party.

Fahid Daoud attended both the University of Cincinnati and Xavier University but received his degree from the University of Cincinnati. As a student, he worked a variety of odd jobs, including stockroom assistant at the Central Trust Company, while living in Bellevue, Kentucky. His brother Basheer worked as an accountant at Clement T. Romer's firm while living in Fort Mitchell, Kentucky.

The brothers all adopted American nicknames to make things easier for others. Fahid became "Frank" because many people mispronuced his name as "Fathead." Beshara became "Charlie," Fahhad became "Dave" and Basheer became "Bish." Some of the brothers even Americanized their last name to David.

After graduation, Fahid and his enterprising brothers had their eyes open for a restaurant purchase. They found a restaurant for sale in the eastern Cincinnati suburb of Mount Washington called Hamburger Heaven. It was across the street from the Elstun Theatre, a one-screen theater that had opened in 1939 and would close in the late 1950s. At the time, in 1963, the restaurant was owned by Joseph Marsh. Marsh had bought it in 1958 from his brother-in-law, Thomas Manoff, a Macedonian immigrant who had operated Hamburger Heaven at its Beechmont Avenue location since 1947 with his wife, Dorothy; his daughter, Jeanette; and his parents, Peter and Sophia. They sold to Marsh because their daughter had moved to San Francisco, California, and they wanted to follow her west. Manoff had come to this country in 1921 at the age of ten and was a restaurateur in Cincinnati and northern Kentucky for nearly forty years.

The four Daoud brothers saw an opportunity and very wisely bought Hamburger Heaven with $1,200 that they scraped together, combining it with cash advances from vending machines. With that purchase came a recipe for Cincinnati-style chili. The chili recipe was formulated by the Manoff family over years of operating their various burger joints and chili parlors. Fahid Daoud said of the recipe that it was a superb one, consiting of sixteen different spices, balanced so that no one overcomes another.

Needless to say, by the 1950s there were enough Cincinnati-style chili recipes going around from Empress copycats. Even though the recipe came

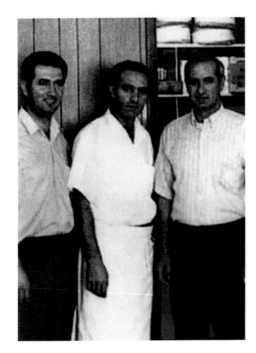

Left: Three of the four founding Daoud brothers of Gold Star Chili. *From left to right*: Fahid, Fahhad and Beshara. *Courtesy of Fahid Daoud.*

Opposite, top: The original Gold Star location after renovation in the 1970s. *Courtesy of the Anderson Township Historical Society.*

Opposite, bottom: The original Gold Star location today on Beechmont Avenue in Mount Washington. *Photo by author.*

from the Manoff family, the Daouds of Gold Star modified the recipe to their own exacting specifications, creating the distinctive flavor known to many today.

Armed with a strong work ethic and a sense of humor, Hamburger Heaven operated well. Unlike the Manoffs, who sold more burgers than chili, the Daouds noticed that customers were ordering more chili than hamburgers. They took advantage of the trend, dropping the hamburgers and serving chili exclusively. That's when they renamed their restaurant Gold Star Chili, after one of the most popular cigarette brands in Jordan (to which the family had supplied tobacco). The name was a suggestion from an older family member. The brothers didn't necessarily think that a cigarette name was the smartest choice, but they didn't want to show lack of respect to their elders and the name stuck. Luckily for them, Cincinnatians were not familiar with the Jordanian brand of cigarettes, and Gold Star became synonymous with high-quality chili rather than high-quality tobacco.

While most of the chili parlors at the time were in downtown Cincinnati or the West Side, Gold Star was the pioneer to bring chili into the East Side. The work pressing Cincinnati-style chili into the local food vernacular had been done by Empress, Skyline and others. So, Gold Star rode on that fuel.

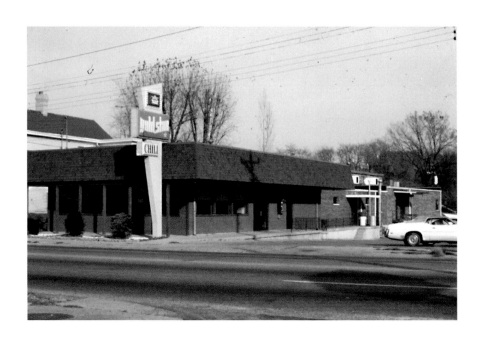

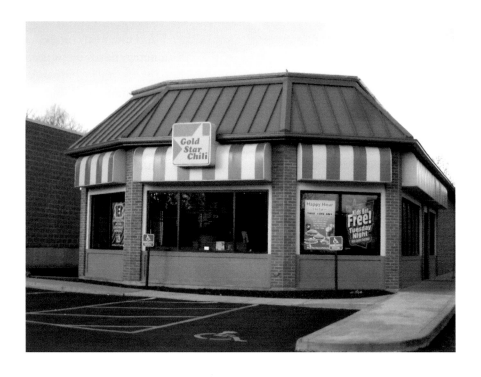

There is today a deep divide between East and West Siders in Cincinnati and their respective customs. Cincinnati-style chili is something on which both can agree, and so we can thank the Daouds for bringing something to the East Side that bridged the cultural gap with the West Side. Very few cultural bridges exist today across both sides of Cincinnati.

Even though Gold Star was one of the last chili parlors, there came another connection to Empress and Dixie Chili in the form of cook Loucas Vesoulis. Loucas had emigrated from Nestoria, Greece. He had been a friend of Nicholas Sarakatsannis of Dixie Chili and worked in that kitchen for a long time. At some point in the 1960s, Nick and Loucas had a quarrel that ended in Lukas leaving and going to Gold Star to work for the Daouds. Loucas helped Gold Star implement their cook-freeze system that enabled them to develop their commissary/franchise supply, and he may have even helped them tweak their chili recipe to what it is today.

Franchising at Gold Star has been a steadily increasing prospect. By 1969, there were 8 restaurants. In 1976, when the Cincinnati Reds were world champions, there were 21 Gold Star locations. The year the Bengals went to their first Super Bowl, there were 48, and in 1989, Gold Star opened its 100th location. Gold Star celebrated thirty years in the chili business in 1995, and in 1999, Gold Star Inc. was named Small Business of the Year by the Greater Cincinnati Chamber of Commerce. The same year, *Cincinnati* magazine awarded Gold Star Chili the winner in an independent blind taste test conducted by five-star chefs among Cincinnati-style chili chains. As of 2011, eighteen descendants by the name Daoud are running Gold Star locations. Only 5 of the nearly 100 locations are corporate, the rest being franchises. Of these nearly 100 locations in Ohio, Kentucky and Indiana, the majority are concentrated in the Greater Cincinnati metro area.

Fahhad Daoud was the first of the founders to pass in 1976, but his brothers picked up the torch and continued operating an ever-expanding business. Fahhad's son, Basheer, was director of development and oversaw the relocation, remodeling or renovation of more than 70 percent of Gold Stars locations, building the chain to more than one hundred locations.

In 1984, Fahid asked his brothers to return to Jordan with him to open up the Gold Star chain in their home coutnry. His other brothers didn't think that the Middle Eastern palate was mature enough for this Cincinnati-style chili and asked Fahid to name it something different. So, in 1985, Fahid opened the first Chili House on Eighth Circle in Jordan. It was the only place in Jordan that served American-style hamburgers, and it was the only place in Jordan where you could buy Cincinnati-style chili, coneys and cheese

coneys. At that time, the only fast-food options in Amman, Jordan, were King Burger and Queen Burger, both of which served poor versions of Kafta-style burgers. In Jordan, the Daouds go by the last name Tueimeh, a more recognizable name than Daoud.

Fahid brought with him the philosophy of franchising, and in 1988, two new Chili House locations opened in Amman on Gardens Street and at the University of Jordan. In 1990, a fourth location opened in Swietieh. All the outlets were run by family members, and all food was prepared fresh rather than frozen and made with only the freshest ingredients. Chili House adopted the commisary model, like Gold Star in Cincinnati, in which all of its products were prepared fresh and distributed to all of its locations. By the late 1990s, Chili House was enjoying success at eight locations in Amman, Irbid and Aqaba.

In 2004, Fahid's son, Sami, returned to Jordan from Cincinnati and became the current CEO. With a passion to lead the company into a new era, he commissioned market studies and focus groups, finding that Chili House needed to make some changes to keep its prominence. Chili House is now open in Syria and Egypt and has plans to expand in five Gulf States: Bahrain, Qatar, Oman, Kuwait and the United Arab Emirates. In December 2012 the Bethlehem Chili House celebrated its grand opening.

As the Daoud brothers aged and their families became larger, they stepped out of the business. In order to take the business and franchising to a corporate level, they hired John Sullivan as CEO in 1990. He had a tough act to follow from the Daoud brothers. He has worked to create consistency in the brand so that a customer recevies the same service, quality and food at each different location.

What marks the "Big Two" chili parlors (Skyline and Gold Star) over the other, smaller chili parlors is their marketing power. TV commercials, billboards, print ads, catchy jingles and slogans initiated the chili wars. Gold Star Chili branded itself as "The Taste that's Taking Over" and even crafted a jingle. Gold Star is the official chili of the Cincinnati Bengals, Rupp Arena in Lexington, Cincinnati Children's Hospital, Cincinnati International Airport and the Lexington Legends.

One of the biggest campaigns in which Gold Star Chili used a sports figure took place in 1993. Tony Perez, then the manager of the Cincinnati Reds and former member of the Big Red Machine, kicked off a promotion campaign for the chili parlor. During his playing years, Perez's nickname was "Big Dog," and since Gold Star was ready to promote its new foot-long cheese coney, it saw a promtional opportunity, naming it "Big Doggie." The store offered

Above: A group of hungry teenagers at the Florence Gold Star Chili location in 1977 eating a threeway fit for ten people. *Courtesy of the Kenton County Public Library.*

Opposite: A waitress adds a heaping mound of cheddar cheese to a Gold Star cheese coney, with a photo of spokesperson Pete Rose overhead. *Courtesy of the Kenton County Public Library.*

customers sixteen-inch miniature Louisville Slugger baseball bats for $1.99, and Perez did various in-store signing sessions for fans. Gold Star also hired another former Big Red Machine player, Pete Rose, for a promotion in the early 1980s, creating a commemorative glass with his likeness.

The second generation of the founders has been actively involved in the business. Basheer Fahhad Daoud, son of cofounder Fahhad Daoud, oversaw the construction, reonvation and relocation of many new locations until he lost a battle with cancer in 2009. Basheer sat in 2005 for an interview with Neal Conan of National Public Radio. Basheer revealed that the chain's commissary produced nearly twenty thousand pounds of food product for the restaurants per day. In 2012, Samir Daoud said that the commissary produces 2 million pounds of chili per year for their ninety-six locations.

Samir Daoud, son of founder Fahid, is the current brand manager for manufactured products at Gold Star. Gold Star chili, frozen and canned, is sold in grocery stores throughout the region, including Kroger's, Biggs, Meijer, Walmart, SuperValu, Jungle Jims, Remke Markets and many others.

In 2006, one member of the Daoud family went outside the Cincinnati chili box to experiment with a new concept. Roula Daoud opened a closed diner on Sycamore in Over-the-Rhine as a new club concept restaurant called Vinyl. She experimented with upscale diner food in a loud, clubby, after-hours environment but was not able to make it sustainable, and it closed within a short time.

Although Gold Star doesn't spend as much money as Skyline on sports sponsorships, it is very actively involved in numerous community charities. A portion of every three-, four- or five-way goes to the Andy Jordan Dalton Foundation, which helps special-needs kids in Greater Cincinnati. Since 2011, the foundation has focused on providing seriously ill and physically challenged children throughout Greater Cincinnati with daily support and life-changing experiences. Gold Star also teamed up with St. Vincent de Paul and Channel 5 WLWT to collect new or gently used coats for needy local families. In 2012, four thousand coats were collected and distributed. Finally, a portion of every can of Gold Star Chili purchased at your local grocery will help fund cancer research through the Cure Starts Now Foundation.

As another example of community involvement and a way to recognize their customers' loyalty, in 2010 Gold Star commissioned local artist C.F. Payne to create a mural for the Bellevue, Kentucky store. Payne is best known for his portraits of celebrities and for his cover illustrations in such publications as *Time, Sports Illustrated, Reader's Digest* and the *New York Times.* C.F. Payne is recognized by many as the "Norman Rockwell of his generation." More importantly, Payne is a Cincinnati native and lifelong lover of Cincinnati-style chili. After running a contest to recruit models, posing and photographing real Gold Star Chili customers and employees as illustration models, Payne's finished mural depicts a daily slice of life in

A large mural by famous Cincinnati artist C.F. Payne adorns the wall of the Bellevue, Kentucky Gold Star Chili Parlor. Close-ups of this mural are placed at select Gold Star Chili locations around Greater Cincinnati, including the Greater Cincinnati Airport. *Photo by author.*

a Gold Star Chili restaurant. From kids having their first cheese coney to teenagers on their first date and a family night out, this painting captures the heart of the Cincinnati-style chili dining experience. The mural will be reproduced for select stores, and several close-ups will be framed for other Gold Star locations.

Gold Star has also been sponsoring the Gold Star Chili Cookoff at Findlay Market for the honorary title of "Chili Meister" since 2004. Second and third prizes are called "Chili Monarch" and "Master Chiliologist," respectively. In 2013, there were thirty contestants who were judged by firemen from Over-the-Rhine's Engine Company No. 5. Gerald Gorman, a returning champion, won. In a first for Belgian/Macedonian fusion food, the Taste of Belgium restaurant, owned by immigrant Jean-François Flechet, had a special Cincinnati chili crepe in its Findlay Market stand in honor of the cookoff.

From a business perspective, Gold Star Chili's growth at 7 percent is outpacing the restaurant industry. A 2011 report from Technomic Inc., a

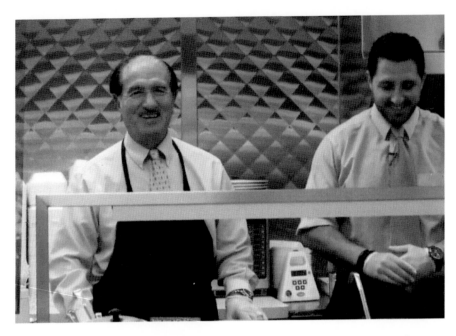

Founding brother Fahid Daoud and his son, Samir, working behind the counter serving Gold Star Chili. *Courtesy of Fahid Daoud.*

Chicago research firm, noted that limited-service restaurants (quick-service and fast-casual) are forecasted to grow at 3 to 4 percent, while full-service restaurants are expected to grow 2 to 3 percent. Gold Star attributes its stellar growth to the addition of new menu items like the double-deckers, burritos and bowls. The most recent Gold Star billboard campaign prominently featured the double-decker sandwich between a cheese coney and a three-way. For growth, the company is also looking to select locations in southeast Indiana; Columbus, Ohio; and Lexington, Kentucky. Regional flavors like Cincinnati-style chili are becoming part of the regional palate, and more and more midwestern restaurants are serving Cincinnati chili.

Today, Gold Star Chili, led by CEO Mike Rohrkemper, employs about 125 in its corporate offices at 650 Lunken Park Drive, near Lunken Airport. Overall, Gold Star Chili has between 1,500 and 2,000 employees. Today, five pillars describe the key attributes of the Gold Star Chili brand: Tradition, Pride, Passion, Value and Neighborhood. Each has a strong connection to the values of the Daoud family.

Samir Daoud and his father, Fahid Daoud, were interviewed in 2012 in a series called *Arab Amerian Stories* by filmmaker Andrea Torrice. Samir,

who was raised in both Cincinnati and Jordan, said, "I just value most that I was fortunate enough to be raised in two different cultures and learn the best of both worlds." His father said that the secret of their success was that each brother contributed according to his ability. They were all for one and one for all. Family is as important to the Daouds as community is to Gold Star Chili.

There is an Arabic proverb that says, "If you drink from a well, you don't throw a stone in it." For the Daouds of Gold Star, it's about giving back to the communities that have given them the ability to pursue the American dream. To Gold Star Chili, the brand promise is that it is the restaurant that best understands and promotes the passionate, personal emotional connection that the people of Greater Cincinnati have with their own homemade dish.

SKYLINE CHILI

If there's one thing that's true about the family behind Skyline Chili, it's that you can't keep them out of the kitchen. Founder Nicholas Lambrinides saw many different kitchens before opening his own at the original Skyline Restaurant in East Price Hill. Nicholas was born in the area of Greek Macedonia in a town called Kastoria. Many fellow Cincinnati chili pioneers came from this area as well, and they are all very proud that this is the area where Alexander the Great was born. Nicholas married Alexandra Sangarangos back in Kastoria but came to America in 1912 to build a nest egg for her to run their family.

He found work first as a cook on the railroad crews, which took him all over the country. In those days, railroad crew kitchens were very unsanitary, and there were many deaths as a result. Every week, the foreman would ask each cook how many of his men were sick or had died, and Nicholas was lucky enough to respond with none. He used a very sanitary method of burying the cooking waste with lime and cleaning the equipment very thoroughly.

The railroad took him to Cincinnati, where he encountered the small but supportive Greek Macedonian immigrant community. So it was Cincinnati where Nicholas chose to spread his American roots and call for his wife. Nicholas later found out that the money he had been sending home had paid for some of his brothers' weddings, and he made an ultimatum that the money would stop and that they should send his wife to America to him.

Nick and Alexandra found a second-floor flat at 423 Plum, where they would build their family of five sons. The street-level flat of their building belonged to

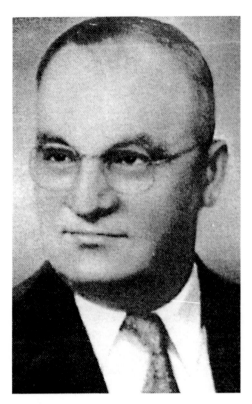

Nicholas Lambrinides, immigrant from Kastoria, Greece, and founder of Skyline Chili and a regional food empire. He was posthumously inducted into the Greater Cincinnati Business Hall of Fame in 2011. *Courtesy of the Price Hill Historical Society.*

the shop of Nick Batsakis, a tailor from Greece who would become a hilarious character in Lambrinides family lore. It seems that Mr. Batsakis would smoke a hookah on his off hours containing more than just rose water.

After nearly ten years of separation, Nick and Alexandra began their family. In rapid succession came Lambert (1923–2008), James (1924–2008), twins Chris (1926–2006) and Bill and finally John, all of whom would have some hand in the Skyline business. The boys would act as translators for their mother, who never spoke English. Nick and Alexandra would be Yiayia and Papou for many of their grandchildren and great-grandchildren.

From 1927 to 1929, while living on Plum Street, Nicholas opened his first restaurant, a short-order diner at the corner of Ninth and Elm Streets. The location was two blocks east of city hall and across the street from the Powell Crosley Builiding. Nick partnered with Christoph Pappas, whose family would run several other restaurants and chili parlors in Cincinnati and northern Kentucky.

This is the original apartment building at 423 Plum Street where Nicholas and Alexandra Lambrinides started their family of five boys in the second-story flat. *Photo by author.*

Nick and Christoph soon closed the restaurant, and next Nick was a cook at the Metrople Hotel restaurant at 609–621 Walnut Street, gaining more experience in American dining successes. The Metrople Restaurant opened recently in November 2012 as the restaurant of the newly renovated 21C Boutique Hotel in the old Metrople Hotel building. Nick's oldest son, Lambert, worked for a while as a cook at another Cincinnati landmark hotel, the Netherland, adding even more experience to the Lambrinides business handbook.

Twins Bill and Chris were servers at St. Peter in Chains Cathedral, just a few blocks up from their flat on Plum Street. One Christmas Eve in 1937, a *Cincinnati Enquirer* reporter snapped an infamous shot of Bill singing while serving mass in the cathedral. The photo appeared on Christmas Day with the caption, "Glory to God in the Highest." The story behind this photo sparked a grandson, Billy Lambrinides, to write a book called *Visions of Plum Street*.

By 1945, the Lambrinides family had moved to a modest home on Beech Street in Price Hill, a few blocks away from the intersection of Glenway and Warsaw Avenues. At that time, Nicholas was working for Tom and John Kiradjieff as a cook at the Empress Chili Parlor on Fifth Street, as were his twins, Chris and Bill, while they were going to "Chili High," Western Hills High School. Bill's Western High yearbook description noted that he "looks like Chris—lots of fun—clean cut gentlemen." Of Chris, it noted that he "looks like Bill—high ideals—contagious enthusiasm." And for John, his classmates said, "Gym Team. Muscle man, mischievous spirit, everything's a joke." Joe Kiradjieff, son of the founder of Empress Chili, was attending Western Hills High School at the same time as the Lambrinides brothers.

After graduating from a vocational automotive school, older son James was drafted into the army. While serving in France and Germany, James sent money back to his father to help save money to open their restaurant.

After several years of working for the first Empress, Nicholas and his sons decided to open their own chili parlor. Armed with a passion for fresh ingredients and a powerful secret recipe that Nicholas had been concocting over the years, the Lambrinides family was ready to challenge the Cincinnati chili market.

So, on October 10, 1949, the Lambrinides family opened the original Skyline Chili Parlor at Glenway Avenue in what was once a dentist office and wholesale furniture store. It seemed that October was a good time to open a new chili parlor—the Kiradjieffs had opened their Empress on October 22, 1922. So it seems that Skyline Chili, like Empress, is a Libra. Local legend has it that the name came from the view of the Cincinnati skyline from the kitchen window. Bill Lambrinides doesn't agree. He said, "We had a skylight in the store. We looked at that and said, 'Let's call it

A ten-year-old Bill Lambrinides belts out a Christmas hymn at St. Peter in Chains Cathedral on Christmas Eve 1937. *Courtesy of the Public Library of Cincinnati and Hamilton County.*

Skylight.'" But then someone noticed the view of the city from a second-floor apartment, which was used for storage, and Skyline it became. The eye-catching logo became a silhouette of the city, with the Carew and PNC bank towers showing prominently.

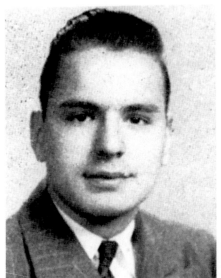

The 1946 and 1948 Western Hills High School yearbook photos of Bill, Chris and John Lambrinides. *Courtesy of the Price Hill Historical Society.*

The location of the first Skyline also followed the unwritten formula of locating near a movie theater. The more movie theaters, the merrier. The area around Glenway Avenue in Price Hill supported not one but six movie houses: the Sunset, the Glenway, the Western Plaza, the Warsaw, the Covedale and the Overlook. The Western Plaza at Warsaw and Entright was only a few blocks

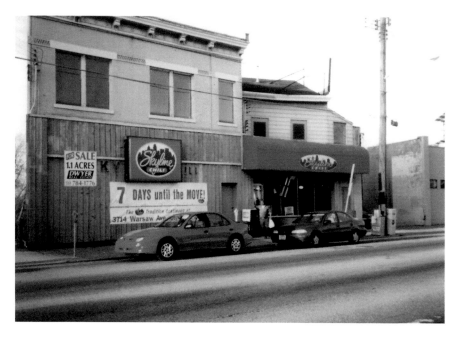

The original Skyline Chili restaurant on Glenway Avenue. *Courtesy of the Price Hill Historical Society.*

from Skyline in one direction, while the Glenway Theatre was only a few blocks away in the other direction. Being across from Seton High School, near Elder High and the grand St. Lawrence Catholic Church didn't hurt business either.

One of the earliest projectionists was a Price Hill real estate man, John Prout, who showed movies in the upstairs of a house that was located where the original Skyline Chili Parlor stood for years on Glenway Avenue. So, Skyline Chili's history is also intimately connected with theatergoers.

The Glenway Theatre at 3823 Glenway Avenue opened in 1914 in the building that was home to Shea's Drugstore for many years. The longest-running theater in Price Hill by far was the Western Plaza, which opened in about 1916 at the corner of Warsaw and Entright. The Western Plaza showed movies for almost fifty years until it was finally closed in 1965. The building was demolished to make way for a Kroger store.

Sunset Theatre on Glenway at Sunset opened in 1946. It was built by the Ackerman family, who owned several of Price Hill's movie houses. By 1960, the Sunset had closed, and the building was the home of the Price Hill Knights of Columbus. Later, it was renovated to become Glenway Chevrolet. It was torn down to make way for the new Carson School.

The Lambrinides' first customer was Alex Chaldekas, a friend and fellow countrymen to the Lambrinides family who would open the ABC Chili Parlor in Covington only a few years later. His bill was a whopping twenty cents, but he paid with a one-dollar bill, which he signed and told his buddy Nicholas to keep for good luck. That first dollar hung in the first Skyline restaurant for many years, but it traveled to Florida with Nick's son, Christy, when he opened the Fort Lauderdale Skyline Chili. Skyline still remains, but ABC Chili is a memory.

Funny as it may sound today, Skyline Chili was not an overnight success. In a mostly German Catholic neighborhood, especially in a pre–Vatican II era—where every Friday was observed a meatless day for Catholics—the first few years were tough for the Lambrinides family. It took a while for the neighborhood to "develop the crave." Billy Lambrinides said, "People would come in and say, 'Is that all you got?'" After free samples, East Price Hill residents developed a ravenous appetite for the spicy chili.

Skyline shortly began advertising to spread the word about the restaurant. One early advertisement used cartoonish images of men in chef hats. This was before the recognizable Skyline logo came into existence. What's interesting is that this early advertisement also promoted Skyline's ability to do catering. And in the early years, Skyline sponsored orchestra hours on WCPO-FM Monday through Thursday and on Saturday. The sponsored show, *For Orchestras Only*, featured a "pleasing arrangement of instrumental standards and old favorites. A solid hour of pleasant listening!"

Before the restaurant made enough money to support the family, son James worked as a salesman for another Cincinnati legacy food brand, the Antonio Palazzolo Company, then on Gilbert Avenue. The Palazzolos were manufacturers of Cincinnati Brand macaroni, spaghetti and egg noodles and were also importers and domestic food and wine distributors. They are famous for their spinach ravioli, which has been served for more than ninety years at the Sacred Heart Spaghetti Dinner in Camp Washington. The Palazzolos were and still are friends with Johnny Johnson, the owner of Camp Washington Chili. Perhaps the Palazzolo family were "Tier 1 Chili Suppliers" of their spaghetti to Skyline and Camp Washington.

The family nature of the original Skyline parlors is evident in the longtime careers of the staff members. The Catholic workers appreciated Alexandra coming in and cooking meatless meals on Fridays for them. Alexandra, who didn't speak English, was a fixture at the Price Hill Skyline Chili Parlor until she was almost ninety years old. The Lambrinides family were very respectful to time off, especially for family reasons. When workers were injured in accidents,

Skyline Chili Parlor

For Holiday Parties

Save time and trouble . . . get ideal foods. We give the finest service to the smallest or largest orders.

FINEST QUALITY CHILI

3820 Glenway Avenue

WA 9408

1949

Left: This early Skyline advertisement shows the marketing prowess of the then young and unfranchised organization. *Courtesy of the Price Hill Historical Society.*

Below: Billy Lambrinides (center) ladles chili for Skyline customers in a 1950s photo inside the original chili parlor. *Courtesy of the Price Hill Historical Society.*

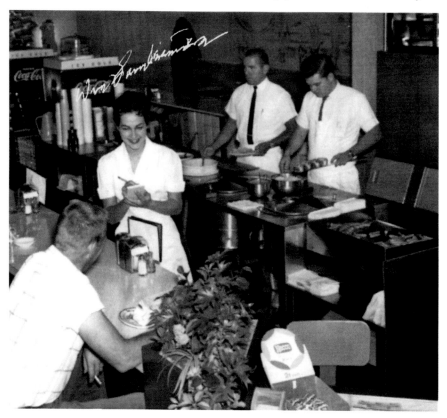

the family would visit them to make sure that they were on the mend, and their jobs were always waiting for them when they finally recovered.

In 1951, taking on another risk, the Lambrinides family decided to open another restaurant at Fifth and Main Streets in downtown Cincinnati, only blocks away from the Empress Chili Parlor, then on Fifth Street across from the Greyhound bus station. The Kiradjieff family said that the second Skyline restaurant was very challenging for them, given their competition with the first in the industry. But then, all of a sudden, the taste caught on.

One of the original workers at the landmark Skyline in 1949 was Nicholas "Joe" Poulos. Growing up next to the Lambrinides family on Beech Street helped to forge a lifelong connection for Joe and his family. Years later, after serving in the U.S. Navy and returning to Cincinnati, Poulos became the very first Skyline franchisee. In 1958, he bought Skyline's second location at Fifth and Main Streets from the Lambrinides family. Old Nick, the founder, lived to see his first franchised restaurant. Joe moved the restaurant to its current 1007 Vine Street location across from the Kroger building in 1962 before the demolition of the building at Fifth and Main Streets. The original site of the first franchise location is now the John Weld Peck Federal Building. Joe celebrated fifty years with the Skyline Chili Corporation in the spring of 2009, and his son, Nick Poulos, took over the business that year, becoming one of the youngest franchisees.

By 1962, when Nick Lambrinides passed on to the "great chili parlor in the sky," the next franchise had been formed. Adeeb Misleh opened the first Skyline franchise in Mount Washington three years before the Daoud brothers would open the first Gold Star Chili Parlor. Misleh and his sons would open more Skyline franchises in Cincinnati's East Side neighborhoods of Walnut Hills, Oakley, Norwood, Montgomery, Lebanon and Fairfax.

Another longtime franchise is the Ludlow Avenue Skyline in the neighborhood of Clifton. Brothers John and Pete Georgeton had immigrated from Agios Demetrios in Greek Macedonia. Taking their training at the original Skyline on Glenway, they opened the Clifton store in 1966. The brothers borrowed a young Steve Yunger, who, forty years later, became the owner of that Clifton Skyline after the Georgetons retired. Just a block down Ludlow from the popular art house Esquire Theatre, it is one of the few parlors that retains the old-time feel. Nestled into a turn-of-the-century Flemish Revival building, it services customers from the nearby University of Cincinnati, Cincinnati State and Hebrew Union colleges, as well as several hospitals. It has become the busiest Skyline location in the company, beating out the previous busiest spot at the Western Hills Skyline.

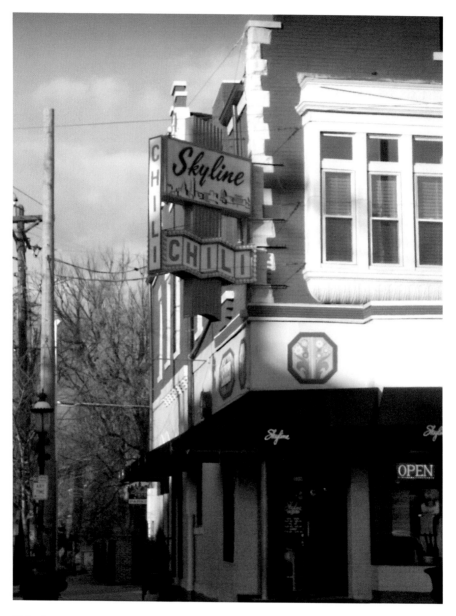

This photo shows the Ludlow Avenue Skyline, an early franchise opened in 1966 by John and Pete Georgeton. It's one of the few Skyline locations today that still keeps the early chili parlor feel. *Photo by author.*

Skyline began expanding its restaurants into neighborhoods where early solo chili parlors had already paved the way for this new chili taste. With Skyline, many of those early entrepreneurs found a stable, consistent brand onto which they could latch their entrepreneurial wagons. In 1974, Pete Perdikakis, whose father had owned the Liberty Chili Parlor in Northside in the 1950s, became the youngest franchisee at twenty-two years old. He ran his Skyline franchise into the early 2000s.

In 1965, Skyline's business also expanded as it began packaging and selling frozen chili and chili with spaghetti to groceries like Kroger. The company built a central commissary to make chili for its various franchise locations. This kept the secret Skyline recipe consistent throughout the small change. The Skyline commissary at 4180 Thunderbird Lane in Fairfield, Ohio, services franchise locations within 120 miles.

The Lambrinides family members were supportive of other neighborhood chili parlors, even after they had plunged into their franchising wave. The current owner of Price Hill Chili, Sam Beltsos, said that they stopped in when he and his father-in-law were just opening their restaurant to give them some business pointers. Grandsons Nick and Tom Lambrinides still stop in every once in a while to have dinner and catch up with their old friend.

In 1984, Skyline celebrated its thirty-fifth anniversary with big fanfare. Within a twelve-hour period, Cincinnati chili-heads had consumed 217,000 cheese coneys. That's more than Skyline sold in all of 1949–50! And they made a four-hundred-foot cheese coney that made it into the *Guinness Book of World Records*.

The majority of the stock in the privately held company was owned by the Lambrinides family members until 1984. In that year, Bill, Chris and Lambert Lambrinides sold 4 percent of Skyline's stock to Thomas Bell, who became chief executive. Bell had been the head of accounting and auditing for the restaurant customers of Arthur Young & Company. There were fewer than thirty locations in 1984 when Bell took the helm. It was Bell's strategic plan to expand the number of stores to two hundred. His long-term vision was to make Skyline a nationwide brand, with as many as two thousand stores.

Bell was enthusiastic for his new strategic vision. He was passionate about the menu, and he was sure that people outside Ohio would develop the crave for Skyline's style of chili. He also thought that the frozen food line was a great asset. Once a new market was developed, they could go in and sell the frozen chili to the area groceries. Bell hoped to accomplish all this while keeping Skyline a private company.

This is a thirty-fifth-anniversary placemat that Skyline issued during the celebration. It commemorates notable moments in Skyline's history, like its first store opening in Fort Lauderdale, Florida, in 1974. *Author's collection.*

The plans took off with blazing speed. Fifty franchised Skylines opened in and around Ohio, but some new restaurants also opened in West Virginia, South Carolina and Florida. The company revamped the frozen goods, now emphasizing that the chili was "Cincinnati-style." By 1985, 20 percent of Skyline's revenue was coming from its frozen food sales, with total sales that year of $7.6 million. Although the company was profitable and growing, there were some red flags that signaled upcoming problems. Several franchises closed because of lack of customer interest. The Hilton Head, South Carolina store closed, as did the Tallahassee, Florida and Zanesville, Ohio stores. Despite this, Skyline kept two locations in Florida and planned to expand into neighboring Georgia.

By 1986, Skyline had nearly fifty franchised units in operation, coupled with nine company-owned restaurants. To ignite more growth and pay down a looming $3 million debt, Skyline decided to sell shares to the public. The company launched a stock offering in December 1986 and raised $4.1 million. Family members and management held majority ownership of 60

percent of the stock. With new capital, the company worked on developing new menu items and opened more stores, both company owned and franchised. Changing from a *Field of Dreams* strategy of building large stores and expecting customers to come, Skyline began focusing on smaller stores from 1,600 to 2,000 square feet rather than the average 3,000 square feet of Cincinnati stores.

By 1988, Skyline had grown to seventy-eight stores, and Bell hoped for a modest growth of fifteen to twenty new locations per year. Sales for 1988 increased to $14.4 million from $12.7 the previous year, but net income shrank, and the national rollout appeared sluggish.

The company went to great lengths to promote the new restaurants far from Cincinnati. In 1989, when the first Skyline opened in suburban Washington, D.C., the company contacted Cincinnati college alumni associations to locate former Cincinnatians in the capital. The Skyline marketing team engineered a group of "chili fanatics" to camp out days before the restaurant opened. By the time the ribbon was finally cut, more than one thousand people had shown up to indulge in a Cincinnati chili frenzy.

Soon after this, Skyline CEO Bell resigned. Lambert Lambrinides, son of founder and then chairman of the company, revealed that the growth had been stagnant. Skyline picked its new CEO from the ranks of its board of directors, naming William G. Kagler to the job. He had resigned as president of the large grocery chain Kroger. Kagler immediately announced that Skyline's growth was overextended, and within months, they had closed a number of unprofitable locations.

Skyline pulled out of markets like Washington, D.C., that proved unsupportable, being so far from where the chain was well known. It built a new commissary and warehouse, replacing the thirty-year-old plant. Kagler ramped up advertising and promotions in Cincinnati markets with the intent to revive the brand recognition in Ohio before pushing for any national presence. Although rival Gold Star had almost the same number of locations as Skyline—seventy to Skyline's eighty—Skyline was apparently what people thought of when they thought "Cincinnati chili."

The number of stores stayed steady through to the mid-1990s. By 1993, Skyline was still running outlets in Cleveland and Dayton, Ohio, and in Indianapolis, Indiana, and Louisville, Kentucky. Kagler planned to put more restaurants in those markets, which would then grow the frozen grocery line.

The brothers Chris, Bill and Lambert Lambrinides retired in October 1994, the same month of its founding, with bittersweet feelings. They had spent the majority of their lives in a chili parlor. They had expanded the

company while retaining the original recipe unchanged. According to Bill Lambrinides, "Dad always said, 'Don't change a thing with the recipe— don't add anything, don't take out anything. It's perfect the way it is.'"

The brothers had helped the board fend off an unsolicited buyout offer in 1997 from a Michigan company called Meritage Hospitality Group. The offer was $25 million. Meritage was a public company that owned hotels and restaurant chains. It had just recently taken on debt to buy a twenty-six-chain franchise of Wendy's hamburger restaurants in western Michigan. Meritage was not profitable and had little cash flow with which to pay its heavy debt load. An interesting twist was that among Meritage's creditors was a well-known Cincinnati financier named Carl Lindner. Lindner was in a position to take over Meritage if it couldn't pay him back. Meritage persisted with a second offer to Skyline. This raised eyebrows that Lindner was trying to get ahold of Skyline through Meritage. Meritage withdrew its offer in April 1997.

The three Lambrinides brothers still kept a 51 percent stake in the company before selling in 1997 to Fleet Equity Partners, a New England investment firm that promised not to change the recipe, which they reportedly keep locked in a safe. The deal was worth $24 million. Skyline became a private company again only eleven years after it became public.

In 2002, the landmark Skyline restaurant at 3822 Glenway Avenue was more than one hundred years old and having structural, plumbing and electrical problems. So, after a study, it was decided that the original Skyline should be demolished and a new restaurant built at 3714 Warsaw Avenue, with a larger seating capacity of 120 and a drive-through window.

For many, this was a sad and sentimental event, so a last meal was planned at the original Skyline before demolition. The last day the original Skyline was open to the public was April 21, 2002. A benefit was held for the East Price Hill Home Improvement Association. On the final day, April 23, tickets were passed out to special customers for a free last meal from 11:00 a.m. to 2:00 p.m.; 150 ladles that had been used at the original location were auctioned off on eBay and reached winning bids close to twenty dollars apiece. That Skyline had developed a cult status was no surprise to management, but this auction was proof.

Now all that's left of the original Skyline is an empty lot across from Seton High School. The Cincinnati Historical Society's curator, David Conzett, was given the historic kitchen door with the old Skyline logo on the glass, and one booth was given to the Price Hill Historical Society on Warsaw Avenue. No historic plaque denotes the location of the small chili parlor

A booth from the original Skyline Chili Parlor sits in a prominent corner of the Price Hill Historical Society like a sacred relic rescued by the Crusaders from the Holy Land. *Courtesy of the Price Hill Historical Society.*

on Glenway Avenue that spawned more than one hundred franchises and started a regional food powerhouse.

What is it about Skyline that has made it the largest chili franchiser in the city? It certainly was not the first nor the last chili parlor in Cincinnati. The owner of Camp Washington said, "Manpower—Nicholas had five sons!" And John Kiradjieff said, "Marketing—Empress thought they could do it on their own. Skyline sought help."

It has indeed become a marketing power. Skyline marketing has created jingles, countless television commercials and sponsorships. It tries to use local customers rather than ship in out-of-town models who have probably never tasted Cincinnati-style chili. Harkening back to the 1950s feel, in 1985, Skyline's marketing released a jingle based on the Platters' 1958 hit "Twilight Time," purchasing the rights for $5,000. It used the voice of local schoolteacher Gerald Brown, formerly of the band Shalamar, for the jingle. Being the first chili parlor to release a jingle, this solidified Skyline as a big player. The commercial was played more than one thousand times in the

first year, and the jingle stuck. Gold Star soon followed with its own. Skyline even showed up in a country song, "Comin to Your Town." The famous jingle was as follows:

"SKYLINE TIME" (TO THE TUNE OF "TWILIGHT TIME")

Whenever you're feeling good and hungry that's Skyline time,
Cuddle up with your one and only (friends and family), it's Skyline time
No other chili has a taste that's so divine, together, at last, it's Skyline time

In 2005, after twenty years, Skyline announced another jingle based on the 1964 Temptations hit "My Girl." Instead of my girl making you "feel this way," the new jingle asserted it was Skyline that "made you feel this way." The intent was to update the jingle to the current mid-range demographic. However, it seems that the original jingle won over, and the 2005 version has disappeared from current marketing promotions.

Skyline is the official chili of many regional professional sports teams and public venues, including the Cincinnati Reds, the Columbus Blue Jackets and the Kings Island Theme Park. It sponsors the Crosstown Shootout, renamed the Crosstown Classic in 2012, an annual men's college basketball rivalry game between Xavier University and the University of Cincinnati.

By 2001, there were 110 Skyline restaurants, mostly in Ohio. By 2004, Skyline's principal markets outside Ohio were Lexington and Louisville, Kentucky, as well as Indianapolis, where it has long had a presence. The company had outlets in Florida by 2004. Florida had strong ties to Ohio, as many Ohioans retired there. Even though the Florida restaurants were far from the home base, they still fed off the brand loyalty and reputation that Skyline had built in Ohio. In 2011, Skyline had a total of 131 stores, 36 of which were company owned and the rest franchises.

Today, there are four descendants of Nicholas Lambrinides who own Skyline franchises: John Lambrinides, great-grandson, owns the Dent, Glenway and Northgate stores; Joe Lambrinides, son of Lambert, owns the Delhi store; Nick Lambrinides owns the Monfort Heights Store; and Mark Keilholz, husband of granddaughter Cindy Lambrinides, owns the Dayton Mall store in Centerville, Ohio.

Grandsons Nick and Tom Lambrinides have run Nick and Tom's Restaurant and Bar in Bridgetown for more than twenty-five years. And great-grandson Tim Lambrinides opened the Silver Ladle restaurant in 2012 in the 580 building on Sixth Street between Main and Walnut. The

restaurant serves a legacy Lambrinides Cincinnati-style chili, called the Silver Ladle Way, as well as a chicken chili.

The fourth generation of Lambrinides family is still contributing to the Greater Cincinnati community. Nicholas Lambrinides III, great-grandson of the founder of Skyline, recently established the Glenway Skyline Scholarship with his brothers Jonathan, Alexander and Jordan. An endowment of $30,000 to the Freestore Foodbanks Cincinnati Cooks program provides a $1,500 scholarship each year to a graduate of the ten-week culinary program, which prepares adults for work in the food industry. The first scholarship went to Berenice Torres, who will use the scholarship to further her education at the Midwest Culinary Institute.

So what were the Lambrinides brothers' favorites ways to eat Skyline? For Bill, it was plain chili with onions. He admitted that in his younger years he ate a lot of three-ways, but as he became older, he had to watch what he ate. For Lambert, it was chili and spaghetti, with onions on the side and hot sauce. And Chris's favorite was a four-way and a cheese coney.

On July 16, 2012, Skyline made history with President Obama's surprise visit to the downtown Vine Street location, owned by Nick Poulos, before attending a town hall meeting at Music Hall. The president ordered a four-way with beans and two cheese coneys with mustard. President Obama asked for no onions. He said, "I'm worried because I have to talk to some people." His visit makes Skyline the only presidential parlor in Cincinnati. But to countless Cincinnatians, Skyline is better than presidential. It's their hometown favorite chili.

UNLOCKING THE FLAVOR SECRETS

Will Rogers once said, "You can judge a city by the quality of its chili." Truly great chili doesn't numb your senses; it excites them with delicious, unique spices. The magic of Cincinnati chili is the way it unlocks the taste buds with varying degrees of sweetness and hotness. There is no such thing as a "five-alarm" Cincinnati-style chili. True Cincinnati chili connoisseurs don't play into the machismo of seeing who can concoct the hottest chili. The true Cincinnati chili chef aims to perfect the spice blend that creates the subtle layers of flavor. Joe Kiradjieff explained, "Your biggest kicker is in your spice formula. But the real magic lies in how all of the ingredients come together. Tomato puree, for example. If you've got too much of that, you've got too much tomato flavor."

Many years ago, a food writer thought that he tasted chocolate and maybe even in licorice in Cincinnati chili. In January 1981, the *Cincinnati Enquirer* posted a recipe for Cincinnati chili that included half an ounce of bitter chocolate. That recipe is said to taste very close to Skyline's chili. The chocolate myth has been spread far and wide, and the taste may come from the type of vinegar used, such as red wine or apple cider. But there is no chili parlor in Cincinnati that uses chocolate in its chili. All say that this is a myth. The licorice reference probably comes from an amount of anise in the chili.

No Cincinnati chili parlor will tell you all the spices in its chili. Some will tell you the number of spices, which seems to hover around eighteen. Some may even go as far as to tell you which spices they use, but it's the ratio of spices that is the big secret. As Spiro Sarakatsannis of Dixie Chili

said, "Spices are typically shipped in liquid or oils. So you have to know the percent by volume of spice to get all the ratios correct. And any time you switch spice brand or a brand switches the percent volume, you have to redo your recipe." So taste, ingenuity and a little mathematics are all required for making Cincinnati-style chili.

The "Holy Trinity" of Greek cooking includes nutmeg, cinnamon and cloves. These are found in Greek dishes like moussaka and pastichio. In addition to the spice trio in the Cincinnati chili sacred blend of spices, there are many more "apostolous," or apostles, that add up to what most chili parlors say is a total of around eighteen different spices. The Cincinnati-style chili uses spices with varying degrees of sweetness—the "sweet apostolous"—like coriander, cardamom, anise, ginger and allspice. These are the same spices you might find in Christmas cookies, gingerbread, pumpkin pie or mulled cider. But to balance and end on a spicy note, Cincinnati chili also uses spices with varying degrees of heat—the "spicy apostolous"—like garlic, chili powder, paprika and cumin. Finally, there are two "herby apostolous"—oregano and thyme—that add a savory balance between sweet and hot. The balance of sweet to hot unlocks the taste buds to give a layered taste sensation. This is a trick that comes from Mediterranean cuisine familiar to the Greek- and Slavic-Macedonian immigrants who ran Cincinnati-style chili parlors.

Dixie Chili and Manoff Chili, for example, claim seventeen different spices in their blends. What spices are potentially included in the secret Cincinnati chili blend? Good candidates are black or white pepper, coriander, chili powder, other types of chilis (like sweet chili), cumin, turmeric, garlic, bay leaves, allspice, nutmeg/mace, paprika, oregano, thyme and celery salt. It is possible that the sweetness some have associated with chocolate may be attributed to sherry or sherry vinegar. Steve Storgion, owner and chief chili maker at U.S. Chili, said in a 2010 interview on Fox 19 that they have "lotsa garlic, bam! We have bay leaves, we got chilis, paprika, chili powder, celery seed, and a ground spice mix." The ground spice mix probably refers to the sweet spices.

Cinnamon, one of the Holy Trinity spices, is the essential ingredient that separates Cincinnati chili from other forms of chili. Although some of the other spices are omitted in various recipes that have been published, the one commonality is cinnamon. It is the link to the native land of the chili pioneers, and it sets the tone for the interplay of sweet and hot spices that are part of the spice mixture.

The variation in flavor across the sweet apostolous spices used in Cincinnati Chili is quite wide. Nutmeg and mace are the only spices that are derived

from the same fruit. Nutmeg is the seed, while mace is the seed covering. It comes from the East Indies and has a warm, sweet, spicy flavor. Pungent and aromatic, cardamom has a fresh, sweet, floral taste that is reminiscent of ginger and lemon. It is commonly used to add distinctive flavor to both sweet and savory dishes. Ginger has a slightly biting, rich, sweet, woody flavor.

The same is true for the spicy apostolous used. Turmeric is closely related to ginger, a root, and has a mild, warming, bittersweet flavor. It has a characteristic aroma that's peppery, with a hint of orange and ginger, like saffron, but it is significantly less expensive. Recently, turmeric has been dubbed a power spice, with many healthful benefits, so it might not hurt to include some in your chili recipe if your current one doesn't call for it. Turmeric, cumin and garlic are from India; cloves, peppercorn and allspice are from the Spice Islands.

Many regions around the world have their own spice blends that circulate in their cooking. In Turkey, Arabic cooking uses a spice blend called Baharat that most probably influenced the Macedonians like the Kiradjieffs. Baharat consists of allspice, black peppercorns, cardamom seeds, cassia bark (or Chinese cinnamon), cloves, coriander, cumin seeds, nutmeg (or mace) and dried red chili peppers or paprika. One blend of Baharat calls for four parts black pepper, three parts coriander, three parts cinnamon, three parts cloves, four parts cumin, one part cardamom, three parts nutmeg and six parts paprika. While this spice blend follows the sweet and spicy balance, all of the hot spices are used in higher ratios than the sweet spices, a formula also found in Cincinnati-style chili.

Groups other than the Greeks and Turks have their own similar stew spice blends, which are heavily guarded. The Chinese use their five-spice blend to add rich, warm, spicy-sweet flavor to dishes. It includes anise, star anise, cinnamon, cloves and ginger. In India, no two curries are the same, but they do share many of the same spices as the Cincinnati chili blend. The Portuguese have their refogo, Haitans have epis, Filiponos have ginisa and Columbians have hogao or guise. Bosnia has a branded blend of spices called Vegeta that they put in nearly everything, including stews and pasta. It includes dehydrated carrots, parsnips, onions, celery, parsley, sugar and cornstarch.

The family of a friend of mine, Manuel, in Puerto Rico have their own blend of sofrito spices. Sofrito—made up of culantro, garlic, onions, Mexican sweet peppers and bell peppers—is added to a variety of Spanish stews and meat dishes. Sent direct from his mother's Toa Alta kitchen, he divides the spices in an ice cube tray and freezes the blend until it's used in a dish. Manuel will lend a spice cube to a friend but will never reveal the exact

formula of Madre Chaly's secret sofrito. For him and his daughter, Dharma, born in Cincinnati, Gold Star Chili is the closest flavor to their Spanish-Caribbean dishes and the only Cincinnati-style chili that they patronize.

The original Greek stew that the Kiradjieff brothers used as a base for Cincinnati chili was probably originally a lamb or goat stew. These types of meat were more common than beef in the mountainous villages of Greek Macedonia. In Cincinnati, on the other hand, beef was readily available, and most Cincinnatians would not have been familiar with lamb or mutton. Cincinnati had numerous stockyards that supplied companies like Kahn's on Spring Grove Avenue in the West End.

The basic Cincinnati chili recipe contains lean ground beef, water, sweet onions like Vidalia, garlic, a type of vinegar, Worcestershire sauce, peppers, bay leaves, chili powder, cumin, tomato sauce, cinnamon and allspice. It's the spice adders and the variations that make it. Variations among recipes use different types of these standard ingredients. For example, using an apple cider vinegar, red wine vinegar or sherry vinegar would impart a sweeter taste to the chili than just a white vinegar. The Greek dishes of moussaka and pastichio typically use white wine or, less commonly, red wine. One legacy chili parlor owner thinks that Skyline uses sherry vinegar to impart the sweetness that people like and that some mistake for cocoa or chocolate.

A higher vinegar taste would give Cincinnati-style chili a flavor like mock turtle soup, which uses a fine ground beef and spices similar to Cincinnati-style chili. Worthmore Soup Company in Clifton, Cincinnati, has historically made its own mock turtle soup and also makes its own Cincinnati-style chili in addition to canning Dixie Chili's retail chilis. Using soy, Vietnamese fish sauce or another similar tangy sauce instead of the standard Worcestershire, would be another interesting ingredient with which to experiment. One could regulate the tanginess and saltiness of the final batch by choosing one of these substitutes for Worcestershire.

Several blogs exist that rate Cincinnati-style chili at the various parlors around town. "Coney Quest," "The Chili Report" and "Chilinati" are a few of the most extensive of these blogs. They are good sites to find the variety of opinions on the tastes of various Cincinnati-style chilis. There are ample opinions to be examined on those sites. Some of the blogs have propagated incorrect history and chili mythology that needs to be corrected in tribute to the true Cincinnati chili pioneers that have come and gone. But the best way to find out is to go around town and sample them for yourself. This is exactly what I did, and I found some

new favorites and had the wonderful opportunity to finally visit parlors I'd never had the opportunity to try.

Cincinnati chili is not Tex-Mex chili, the chili invented in and now the state dish of Texas. In 1870, DeWitt Clinton Pendery arrived in the then untamed Fort Worth, Texas. Oddly enough, it was from a starting point in Cincinnati that Mr. Pendery trekked halfway across the country in a horse-drawn stagecoach. Good riddance to that—we had a brighter and more colorful chili ahead of us. But we must, as chili historians, give a historic nod to Mr. Pendery for his invention of chili powder.

Like the Greek- and Slavic-Macedonians who first presented Cincinnati-style chili to a mostly German crowd, Texan cowboys didn't know how to take Mr. Pendery. His East Coast appearance—long frock coat, tall silk hat and carefully waxed handlebar moustache—didn't fit the chap-wearing, spur-sporting wranglers in Texas. By 1890, Pendery was selling his own unique blends of spices to cafés, hotels and citizens. Circulars, carried on the stage line, were one of his means of advertising. They described and extolled his "Chiltomaline."

Chiltomaline is the combination of ground chile pods, cumin, oregano and other spices. This, a forerunner in world seasonings, enjoyed more than mere culinary favor. DeWitt Clinton wrote of the medicinal benefits of his condiment and of its acclaim from physicians: "The health giving properties of hot chile peppers have no equal. They give tone to the alimentary canal (the digestive tract), regulating the functions, giving a natural appetite, and promoting health by action of the kidneys, skin and lymphatics."

Joanna Manoff, the wife of Petro Manoff's great-grandson, Todd, said that the secret to the long life of the early chili pioneers is in the spices. Joanna is a certified aromatherapist. She attests to the life-giving properties of the blend of spices used in Cincinnati-style chili. Just as matzo ball soup is considered Jewish penicillin, the spices of Cincinnati-style chili are like their own Macedonian medicine. Some people blame indigestion on the spices of chili. But the spice blend is the healthy part, similar to Mr. Pendery's description of the healthful benefits of chili powder.

My own family's Cincinnati-style chili recipe has Empress Chili ties. My mother started her career as a secretary at Western Southern Life on Fourth Street, a few blocks over from the second Empress Chili Parlor at Fifth Street. She worked with a man from Ludlow, Kentucky, who gave her the recipe. This co-worker left Western Southern to open his own chili parlor in Ludlow, Kentucky.

FLORA'S CINCINNATI-STYLE CHILI

1 quart water
2 pounds ground chuck
1 6-oz can tomato paste
2 large sweet onions, chopped finely
3 large bay leaves
½ teaspoon cumin seed or powder
½ teaspoon red pepper
1 teaspoon cinnamon
1 teaspoon black pepper
1 teaspoon Worcestershire sauce
1½ teaspoons ground allspice
1 tablespoon salt
2 tablespoons chili powder
1½ tablespoons apple cider vinegar
1 clove garlic, chopped

Crumble raw meat in the cold water—do not brown the meat before. Add all ingredients and bring to a boil. Simmer three or more hours. Add whole red peppers if desired (this is a carryover from Empress, which does use whole red peppers in its chili).

Based on research of the various published Cincinnati-style chili recipes, as well as revelations from owners of Cincinnati-style chili parlors, the following is my estimation of the eighteen secret spices used in Cincinnati-style chili. The "holy trinity" consists of cinnamon, cloves and nutmeg. The sweet apostolous consist of ginger, allspice, cardamom, anise and coriander. The spicy apostolous are cumin, paprika, chili powder, turmeric, a bay leaf, garlic, black or white pepper and celery seed or mustard seed. Finally, the herby apostolous are oregano and thyme.

So this, in my estimation, is the secret blend of Cincinnati chili spices. The only way to truly find the best mix and ratio is to experiment yourself. Now like Thomas Manoff, and anyone else who came from the Empress Chili Parlor, you know the spice blend, but not the ratios. If you play around with roughly a 2 to 1 ratio of the spicy apostolous to the sweet apostolous you're well on your way to developing your own Cincinnati-style chili. Don't forget apple cider vinegar, worchestershire, tomato paste, and sweet onions. Enjoy the experimentation and the crave that took over Cincinnati!

CINCINNATI CHILI PARLORS

THE REST OF THE STORY

The whole story about Cincinnati chili cannot be told without the tales of the independent parlors, most of which have come and gone. Before the big chili chains of Gold Star and Skyline took over, nearly one hundred chili parlors had come and gone. Almost every Cincinnati neighborhood had its own independent chili parlor. They were then, like they are today, places that captured the essence of the neighborhood. People met to discuss high school football, read the daily news, talk politics or gossip. Before the saturation of modern fast-food restaurants, chili parlors chose locations near neighborhood theaters, a formula set by the brothers Kiradjieff of Empress.

Thomas Manoff, grandson of Petro Manoff, who helped to found Dixie Chili and then founded Strand Chili, both in Newport, said it best: "The West Side is chili country. You can't drive anywhere on the West Side of Cincinnati and roll down your window without smelling chili." The Manoff family are the family behind the Gold Star Chili recipe and the first family to take Cincinnati-style chili east of what is now Interstate 71 to Cincinnati's East Side. When they served their Cincinnati-style chili—an Empress-descended recipe—at Hamburger Heaven in Mount Washington, the taste had not yet spread to the East Side. "We sold more hamburgers than chili," Mr. Manoff said. It wasn't until the four Daoud brothers bought Hamburger Heaven in 1965 that they started seeing the trend of more chili than burgers being consumed. So those East Siders can thank the Manoff family for bringing the chili crave east and the Daoud brothers for making it stick.

But as we know, Cincinnati chili started downtown in 1922 with the brothers Kirdajieff at the Empress Chili Parlor. Cincinnati's bustling downtown was where the first-generation Greek Macedonian immigrant population congregated in the years after the tragedy of World War I. Downtown had an endless stock of boardinghouses where rooms could be rented economically and temporarily until money could be made. The railroad yards and plethora of hotel restaurants also gave springboards for the closely knit immigrant group as they worked to stake out their claims.

In 1907, the Holy Trinity Greek Orthodox Church was formed to support this new and growing group of immigrants. Today, the Holy Trinity–St. Nicholas Greek Orthodox Church on Winton Road in Finneytown is still the backbone of the Greek community, and it is where the majority of our city's fantastic chili entrepreneurs worship. This supportive group of Greek Macedonian immigrants in Cincinnati became known throughout the country, and many stopped here instead of staying on the East Coast after stepping off the boat. Family members continued to host other family members in a chain of immigration, and an important group crystallized.

In a newspaper interview in 1979, the then pastor of Holy Trinity–St. Nicholas Greek Orthodox Church, Father Constantine Mitsos, recited the chili legacy of his parishioners:

> *Of course there are the Lambrinides brothers of Skyline Chili. And there are others who own Skyline franchises. The Georgeton brothers (who owned the Clifton Skyline franchise on Ludlow Avenue). Chili Time in St. Bernard is run by Harry C. Vidas—you've got to say the middle initial because there are so many of them—and his brother Pete, and a nephew Ted. Chili Town across from Shillito's is the Demas brothers, George and Tim. There is Camp Washington Chili, and Price Hill Chili—oh yes, and Delhi Chili, White Oak Chili and Blue Ash Chili. Across the river is Covington Chili and Dixie Chili.*

A tight-knit faith-based community made "sharing" Cincinnati-style chili recipes easy, but it sometimes led to family squabbles. There are more than a few stories of families leaving one chili parlor to start another one across the street or down the block from their relative's parlor. But for those who harbor the crave, this community is responsible for creating a great chili momentum. That momentum allows a Cincinnatian today to travel no more than a few miles within the loop of Interstate 275 to find a booth or a stool at a chili parlor.

Empress was the lone game in town for nearly a decade in downtown Cincinnati. According to John Kiradjieff, son of cofounder Joe Kiradjieff, the brothers actively recruited and sponsored the immigration of other countrymen. Empress became a chili parlor incubator. In addition to being incredible entrepreneurs, the Kirdajieff brothers were also ambassadors to their people. They had found something good in Cincinnati, and they wanted to share this with their less fortunate countrymen and countrywomen back home. The battles between the Greeks and Turks during World War I had been so devastating to their people—separating and shrinking families due to tragedy. America, and Cincinnati in particular, gave a great opportunity for a fresh start in life.

As was mentioned, the Empress provided training ground for many immigrants, who went on to start their own chili parlors. Nick Sarakatsannis founded Dixie Chili in 1929 in Newport, Kentucky. Steve Andon founded Camp Washington Chili in 1940. Petro and Thomas Manoff founded Strand Chili, Tip Top Hamburgers and Hamburger Heaven, all of which served Cincinnati chili. Harry Vidas founded Chili Time in 1943. Samuel and Carl Gerros founded Latonia Chili, which spawned Price Hill Chili. All roads for chili parlors lead back to Empress. That's not to say that the recipe hasn't morphed into many distinct tastes of Cincinnati chili as it changed hands. Even though each parlor has its own distinct taste, and every native can articulate why they their favorite tastes better, there's really not a whole lot of difference in the recipes. For natives, maybe it's not so much about the taste of their favorite Cincinnati-style chili but rather the atmosphere of the chili parlor and the friendliness of the staff that makes it a favorite.

The earliest chili parlor to pop up in downtown Cincinnati after Empress was owned by Macedonian immigrant Paul Taleff. In 1929, the same year that Nick Sarakatsannis opened Dixie Chili in Kentucky, Taleff opened the small restaurant at 601 West Sixth Street that he would name the Famous Chili Parlor. Taleff's parlor operated there until the mid-1950s. He had owned a small restaurant the year before at 711 West Court Street in Cincinnati's dense German immigrant West End, and he would continue to operate that business with a partner, Mitroff, as well as another restaurant at 614 Mound Street with another partner, Nastoff. The Taleff family would be in the chili parlor restaurant business for more than thirty years. Paul's son, Daniel, became a cook at the Famous Chili in 1939, and another relative, Boris Taleff, started there as a waiter. That same year, Pete Taleff started a restaurant at 307 Sycamore. Norman Taleff opened the Empire Chili Parlor with partner William Sotir in the early 1950s at 7 East Thirteenth Street near the Empire Theatre on Vine Street. Then, in 1965, Norman Taleff

went across the river with partner James Smith to open another Empire Chili Parlor at 1746 Monmouth Street in Newport, Kentucky. This back and forth with chili parlors and restaurants with different partners over the years was common in the evolution of Cincinnati chili.

To add perspective to the chili timeline, by 1946, there were more than half a dozen other chili parlors in downtown in addition to the Kiradjieffs' Empress and Taleff's Famous Chili. There was Main Chili Kitchen and Sandwich Shop at 220 East Sixth Street, owned by William Gaz. Chili Kitchen at 2509 Gilbert Avenue and 607 Walnut Street was the first chili parlor to have dual locations. Cincinnati Chili Incorporated at 639 Vine Street was run by Fay Snapps, Dalton Chandler and Leonard Lipshutz. Tom's Chili Parlor at 1535 Central Avenue, near the old Dolly Varden Theatre, was run by Mrs. Theresa Drivakis. B&M Chili Parlor at 3200 Colerain Avenue was a partnership between George Perdikakis, Charles Balli and Steve Moraites. Before opening Crystal Chili in Newport, Dixie Chili cousins Charles and Art Sarakatsannis ran the Crystal Grill at 244 West McMicken near the Imperial Theatre. And that's not counting the several suburban chili parlors in Oakley (Oakley and 20th Century Chili), Camp Washington, Northside (Liberty and Park Chili), St. Bernard (X-L Chili Kitchen, owned by William E. Williams) and East Walnut Hills (Orpheum Chili Parlor).

By 1953, only a few years after the second Skyline Chili was opened at 506 Main Street downtown, there was a total of eighteen chili parlors listed in Cincinnati. The West End had Court Street Chili Parlor at 753 Court Street and West End Chili Parlor at 701 West Court Street. Main and Liberty Chili at 1447 Main Street was only a few blocks up from the new Skyline Chili. The Empire Chili Parlor at 7 East Thirteenth Street fed moviegoers coming to and from the nearby Empire Theatre. George's Chili Parlor at 266 West McMicken Avenue fed patrons from the nearby Imperial Theatre. Clearly, the successful formula for opening a chili parlor had been made in Cincinnati.

It didn't take long for chili parlors to move out of downtown. In 1936, an Oakley Chili Parlor at 3091 Madison Road, owned by George and Mary Manoff, was feeding movie theater customers. They sold in 1938 to Norman Phillip Bazoff, who opened Park Chili across from the Park Theatre in Northside's bustling entertainment district.

In 1940, a new modern movie theater was built on the square in Oakley, and in a small shop at 3025 next to the movie entrance at 3023 Madison Road, the 20th Century Chili Shop, operated by Mrs. Catherine and John Pashal, filled moviegoers' bellies with Cincinnati chili.

This image shows the 20th Century Theatre on Madison Avenue in Oakley. The small shop to the left of the theater entrance housed the 20th Century Chili Shop in the 1940s. *Photo by author.*

Another theater, the Ambassador, had opened on Madison Road in 1913 in Oakley, but the presence of this theater justified the opening of a third chili parlor, Shorty's Chili Kitchen at 3158 Madison Road, owned by Frank B. Knefel. That location would later become one of a chain of Chili Company restaurants opened by Pete Poulos in the 1980s.

Poulos's first location was in White Oak, and he successfully franchised to a total of twelve locations. Poulos's family had many years of experience in the restaurant and entertainment business and recognized fast food as a growth area. Growing in the poor economy of the early 1980s, Chili Company was afforded many good locations for expansion where other restaurants had failed, and manufacturers offered great discounts on equipment packages. Pete's goal was to have one hundred locations within a one-hundred-mile radius of Cincinnati, but that goal was never realized.

The menu was famous for its slaw dogs and slaw ways, which added homemade coleslaw in between the cheese and chili of coneys and three-ways. It is interesting that no chili parlor has tried to add sauerkraut instead of slaw to create a kraut coney. I guess that's too crazy of a fusion food for Cincinnati. Nick Poulos runs the Vine Street Skyline franchise.

Park Chili can claim to be the only Cincinnati chili parlor operating in its original corner flatiron building, having been there since 1937. Before that, it was one block south on the opposite side of the street in what is now the Northside Savings and Loan Building. Positioned on Hamilton Avenue on an eclectic street of farm-to-table restaurants, music bars, tattoo parlors, hair salons and vintage stores, Park Chili services people from all walks of life. A cheese coney can still be had for only $1.45, and the special is usually $5.00, so anyone can afford "great food at great prices," as Park's motto exclaims.

The Park Theatre opened in 1913 and claimed that it was the first theater with air conditioning for individual seats. It originally housed a barbershop and a pool hall in the same Flemish gabled building. In the 1970s, the theater changed names to the Alpha Fine Arts Theatre and began showing X-rated films until it closed in the 1980s. But being directly across from this long-running neighborhood theater made Park Chili an excellent location.

Bazoff's daughter-in-law—who helps him and his son, Norman, run Park Chili—said, "It's not fast food, but it's damn good food. It's love at first bite." Even though its décor is caught in the 1950s, the atmosphere is friendly, and the owners provide great conversation and comic relief to patrons.

Phillip Norman Bazoff now runs the chili parlor. His father, Norman Phillip, founded Park Chili in 1937. The junior Bazoff graduated from the

nearby University of Cincinnati in 1963 with plans to become a lawyer. His father's passing made him stay in town and help his mother run Park Chili. Phil's sister married into another Cincinnati chili family, the Kiradjieffs of Empress, for a brief time.

If imitation is the highest compliment, Phil Bazoff is not happy about it. Bazoff claims that he was the first to come up with chili cheese fries, long before Gold Star or Chili Time offered them. He has added another unique touch to the menu: the "Mess," a mix of eggs, home fries, vegetables and meat of your choosing. "Bob Evans calls it the Country Scrambled. Jimmy Dean's got it frozen; it's called the Iron Skillet. They all copied that from me. I've been making it for more than forty years," said Bazoff. Like any good chili parlor that serves breakfast, customers can also order goetta, another Cincinnati hometown favorite, at Park Chili.

Another difference to the chili at Park is that Phil browns the meat instead of boiling it like the majority of the other parlors. To many Cincinnati chili purists, that's a no-no because it can leave a charred or burnt taste to the chili, overriding the subtle spices. However, the earliest legacy chili parlors, like Empress and Strand Chili, browned their meat.

Another Northside chili parlor, the Liberty Chili Parlor, was only a few blocks south of Park Chili on Spring Grove Avenue, which intersects Hamilton Avenue. Operating inside the old Liberty Theatre, there was a third theater, the Americus, nearly at the midpoint between Liberty Chili and the Park Chili Parlor. Filled with bars, saloons and bowling allies, the Northside entertainment district was more than capable of supporting two close chili parlors. It seemed like Liberty Chili was a training ground for immigrant restaurateurs. It had many different owners over the years—James and Menca Peterson (1938), Kime Maumoff (1941), Andrew Nelcow (1942), Peter Taleff and Andre Nelcoff (1943) and Lazar Kostoff (1953).

One short-time owner of the Liberty in the early 1950s was George N. Perdikakis, who went on to own several chili parlors. He wrote about his immigrant experience, not too dissimilar from what many others who came during the turmoil in Greek Macedonia during World War I experienced:

I was orphaned at age eight by the early death of my father, Nicholas John, leaving my mother Eleni, and four sisters in Mousconicia, Asia Minor. We struggled to hold our family together, the fate falling on me to fill my father's role. With the curse of the first World War, I tried any odd job to help the family survive. One job was helping the underground

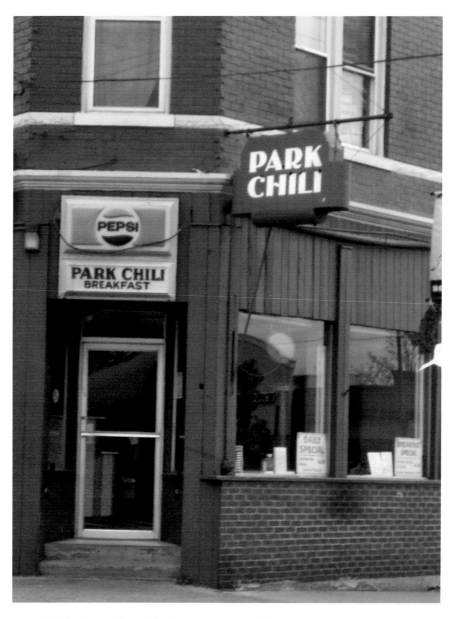

Above: This is Park Chili at 4129 Hamilton Avenue in Northside. It has been serving loyal Northside customers in the same turn-of-the-century flat-iron building since Phillip Norman Bazoff founded it in 1937. *Photo by author.*

Opposite: This is the Liberty Theatre in Northside, which became the Liberty Chili Parlor in the early 1940s. *Author's collection.*

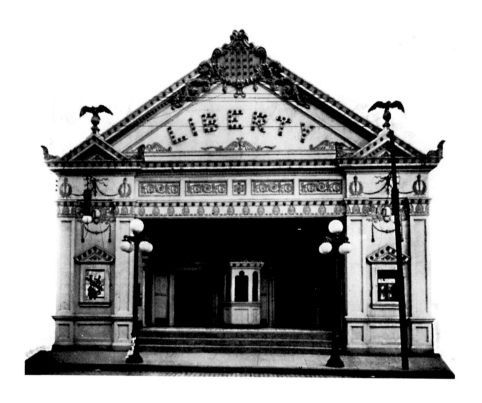

with leaflets and newspapers which resulted in my being jailed and beaten. The rest of the family escaped to the island of Mytilini for safety. This was just prior to the forced evacuation by the Turkish Government leaving behind our home and beautiful island. I risked my life to escape to Mytilini and join my family. While fleeing I was practically naked and very lucky to avoid capture, a moment deciding my life, family, and future fate.

A family friend spoke of America. I talked to my mother, her eyes full of tears and motherly pain of leaving to a new corner of the earth. I, her sixteen year old son and only hope of a future, was left to travel six thousand miles without a single relative. Standing at the pier, I held my mother, trying not to bend to sorrow and hoping she would survive. She died only a year after my departure to America.

I settled in Aliquippa, Pennsylvania and worked in the steel mills for twenty-two years. I was able to provide for my three sisters, Maria, Felitsa, and Despina in helping them settle their own families. Thank God I was

able to unite with a devoted person, Eftcha Mavridoglou, originally from Mousconicia, and my village. We were married in 1940 and settled in Cincinnati to operate several restaurants.

Chili parlors continued to move up Hamilton Avenue from Northside into the next neighborhood, College Hill. A relative of Lazar Kostoff (onetime owner of the Liberty Chili Parlor), Louis D. and his wife, Marcella Kostoff, ran Lou's Chili Parlor at 5842 Hamilton Avenue to satisfy movie customers at the Hollywood Theatre across the street. By 1945, Cincinnati-style chili had reached North College Hill at Tom's Place, owned by Tom Connerton, at 6501 Simpson Avenue, which served sandwiches, Coney Islands, fish oysters, mock turtle soup, chili and Wiedemann and Schoenling beers on tap.

Just as chili parlors moved to Northside, they also moved into Clifton, the neighborhood around the University of Cincinnati campus. A Mohawk Chili Parlor at 281 West McMicken at the foot of Clifton was run by Brack Sizemore in 1965.

One of the first solo chili parlors in Clifton was Acropolis Chili, founded in 1977 by Tom Mirkos (1934–2013). Mirkos was born in Kastoria, Greece, to John and Kiryascha Mirkopolis. He came to this country in 1952. The first location of Acropolis was on Ludlow Avenue next to the bar Mirkos also owned, the Golden Lions Lounge. It basically served as a feed stop after his bar closed. Mirkos opened a location on the opposite side of campus at 233 Calhoun Street that he passed on to his son-in-law, Joe Kennedy, in 1987. It was a late-night hangout for the hip young college crowds and served a dark, medium-thick, sweet and mild chili. With no table service, customers came up to a window and were served cafeteria-style.

Unfortunately, Kennedy inherited a highly contested area on Calhoun Street. In 2004, he was forced out by eminent domain so that the University of Cincinnati could demolish it for a new urban village south of campus. Backed by the Clifton Heights Community Urban Redevelopment Corporation, it envisioned $150 million in new investment and market-rate condos with views of downtown. Acropolis Chili, along with other University of Cincinnati longtime icons like Inn the Wood Tavern and Mr. K's, were demolished. The bare land sat vacant for more than five years until the urban village plan was finally built in late 2012.

WEST SIDE CHILI HIGHWAY

Thomas Manoff was right about smelling chili anywhere on the West Side. The almost eight-mile stretch of Glenway Avenue has been called the "Chili Highway" or the "Route 66 of Chili," and rightfully so. In its day, Glenway Avenue housed six movie houses—the Western Plaza, the Glenway, the Sunset, the Warsaw, the Covedale and the Overlook.

Today, there are seven chili parlors along Glenway Avenue, one for every mile—the Price Hill and Westwood Skylines, Sam's Chili, Price Hill Chili, the Western Hills Gold Star, J&J Restaurant and an Empress on Werk Road in a strip shopping mall that can be entered from Glenway.

J&J's was founded in 1964 by Jim Mintsoulis and John Asilov at 6151 Glenway. Before it moved into its newer strip mall location at 6159 Glenway, it had an old plastic horse above the grill and a mix of wood paneling and European cast-iron sconces. The chili recipe was created by Asilov and his brother, and it falls between Skyline's sweetness and Gold Star's meatiness. It serves a wide variety of breakfast offerings all day, Cincinnati-style chili, double-deckers and sandwiches. Signatures are the Big Spero and Highlander Burgers.

Other Glenway chili parlors that came and went included Tip Top Hamburgers at 4002 Glenway, which opened in 1947, two years before the first Skyline. Opened by Tom Manoff and his brother-in-law, Frank Bedell, this was the recipe that made its way to Gold Star chili. Near that location at 4010 Glenway Avenue was Glenway Chili, opened in 1953 by S. Evon Vulcheff. Glenway became Hilltop Chili in 1958.

A Covedale Chili Parlor operated near the Covedale Theatre on Glenway Avenue for many years. A Crookshank Chili Parlor at 5060 Crookshank Road near Glenway existed until a few years ago.

Delhi Chili at 4875 Delhi Pike closed in May 2012 after its owner, Demetrios Christos "Jim" Kostoploulos, passed on to the "great chili parlor in the sky." He had founded the place in 1963 and spent almost every day there over the last forty-nine years. He built the chili parlor into a successful restaurant to support a family of three kids, educated them and set them on paths to good lives. He spent his last minutes where he spent so many long hours, serving jokes to his customers as a side to their chili, double-deckers and goetta. Delhi Chili is known for its "Hog Way," a sort of breakfast concoction made up of hash browns, eggs any style and your choice of sausage links, sausage patties, bacon, ham or geotta, all topped

with a three-, four- or five-way with Cincinnati-style chili. Certainly not a dish for a small appetite, it's like something you might find on the show *Man v. Food*.

PRICE HILL CHILI

You can't talk about independent chili parlors on the West Side without talking about Price Hill Chili. Founded in 1964 by Greek immigrants Sam Beltsos and his father-in-law, Lazoros Nourtsis, it is a West Side institution. Locals shorten it to "PHC." Sam bases his business on good prices and good quality, never sacrificing on quality for profit. You can find anyone from an Elder High team meeting to a group of women having a cookie exchange. A woman with a young daughter comes in and sees Sam. He stands up and greets her with a hug and kiss and a "Kala Christougena"—"Merry Christmas" in Greek. He asks about her mother, but she says she's not doing so well. The woman introduces her daughter, and Sam's face lightens with a smile, saying that he remembers when she was a much younger girl.

Sam Beltsos was born in the small village of Monopoulon just north of Kastoria. Just like Johnny Johnson of Camp Washington, his village was bombed out by the Communists in the 1950s. Their village was so devastated that it was abandoned. Sam's oldest two brothers had immigrated to Boston, Massachusetts, already, and as the "bambino" of the family, he followed them in the 1950s to escape the devastation back home.

Sam lost his father at age eleven, so his father-in-law became the only father figure he ever really knew. Sam's parents were Steve and Maria, and in their village, they operated a café called the Café Kefenio—it, too, was destroyed by the Communists. It was always Sam's dream to have his own restaurant.

Sam had to take French and Latin in Greece as a kid, so picking up English was no problem for him. But his son, Steve, said that going to school was a bit of a culture shock because both his mother and grandmother spoke only Greek in the home, so he spoke no English upon entry into grade school.

The man who became Sam's father-in-law was Lazoros "Pops" Nourtsis (1908–2003), also from a village near Kastoria. He left his parents, Christof and Sophia Lousis Nourtsis, behind for a better life in America. He and his wife, Thelma Markos, had immigrated to the United States and lived with Nourtsis's uncle, Carl Gerros, in Latonia, Kentucky. Carl, with his father,

Samuel Gerros, had opened Latonia Chili Parlor, and it gave Lazoros a training ground to learn the chili business. Nourtsis had a brother, Pete, who settled in Chicago; a daughter, Ezmine; and two sons, Sam and Steve.

Sam Beltsos started working at the Walgreens lunch counter downtown. Every pharmacy in those days had a lunch counter and a soda fountain. It was a full-service grill serving sandwiches, entrées and soups. He learned the recipes for those soups at Walgreens and serves them at Price Hill Chili today.

He was almost fired from Walgreens for the creative way he cooked a leg of lamb. One time, when the owner had a leg of lamb, he had Sam cook it. This Sam gladly did, adding his own rub of Greek spices, not common to the average American palate. One obviously non-Greek customer complained about the spices used, and the manager asked Sam why he spiced it that way. His reply was, "I am Greek. That's how we cook." The owner laughed off the ordeal and became good friends with Sam.

In the 1960s, Sam decided to look for a place to open his own restaurant. After a short search, he found a vacant place on Glenway Avenue at the corner of Guerly that had formerly been the Bellanopoly Italian Restaurant. He told his father-in-law, and in 1964, they founded Price Hill Chili. The original place had four tables and nine barstools. But business soon made them remodel and enlarge. In 2007, they expanded the Golden Fleece side into a glass-enclosed space that offers a crow's-nest view of Glenway Avenue from Prout's Corner. Their chili parlor now seats close to four hundred.

Sam and Pops worked together every day. Even up to his retirement, Pops would come to the parlor every morning at 9:00 a.m. He was very proud to see the success of his son-in-law. Lazoros's grandson and namesake, Lasoros, plays the bouzouki, similar to a mandolin, at the Panegyri Greek festival and travels with guitarist Nick Vidas of the Chili Time family to festivals and weddings all over the country.

The Overlook Theatre, at the time, was located across the way from Price Hill Chili in a lot that is now a United Dairy Farmer. The Overlook opened in the early 1930s on Cleves Warsaw. Mr. Penn, the manager, had a son-in-law who was a barber, so it was the only movie theater in Price Hill with an attached barbershop.

Only a few miles away on Glenway Avenue, the Covedale Theatre still brings in a lot of pre- and post-show business. On April 6, 1947, Easter Sunday, the Covedale Theatre showed its first film and featured first-run premier movies throughout the 1980s. In 1997, it was purchased by the Cinema Grove Company, based in Atlanta, Georgia. Patrons sat at tables

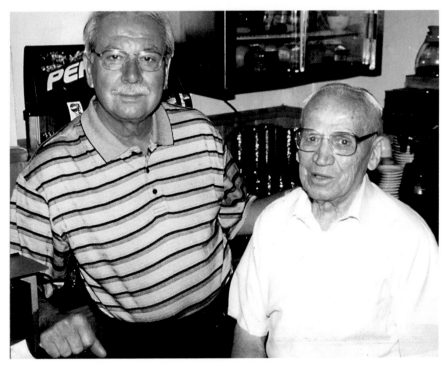

and chairs, and the Cinema Grill offered a casual dinner menu during the movie. It is now home to live theater, featuring the best in local performers and performances. Its season subscription is the largest in the city of any theater, even over the prestigious Playhouse in the Park.

The bar next door to Price Hill Chili in the 1960s was called the Guerly Inn. Sam had trouble with its clientele. It was a hookup bar, not a family place like his chili parlor, and there was a bookie who would run gambling pools. The bartender at the time had an attitude toward Sam, so he decided to buy the bar out from under him. After firing the troublesome bartender, Sam renamed the bar the Golden Fleece after the Greek myth of Jason and the Argonauts and connected it to his bar. It has since then only been a family bar, and he has never had any problems.

Sam's son, Steve Beltsos, like all the other chili pioneers, emphatically said that they have no chocolate in their chili. One of his friends uses chocolate in his chili because it gives it a nice sheen. Who cares about sheen when you're going to cover it with delicious cheddar cheese?

Today, it's like eating at someone's home, with the walls adorned with personal photos and family sports memorabilia. Sam is a big boxing fan and has a photo of a boxing match that happened in Boston when he was there, as well as several boxing gloves.

Sam was honored in November 2012 by being chosen as the grand marshal for the Price Hill Thanksgiving Parade. Price Hill had recently celebrated the fiftieth anniversary of the parlor, and it seemed fitting. The West Price Hill Civic Association considers Sam and his family a great asset to the community and Price Hill Chili an important part of the neighborhood. He originally wanted his sons to march instead of him, but they persuaded him that it was his honor and not theirs. He paraded down Glenway Avenue from Ferguson Street to St. Lawrence Church on Warsaw Avenue.

Sam is friends with the Lambrinides family—the brothers and the grandsons, who own Nick and Tom's bar. They come in every once in a while

Opposite, top: Proudly standing behind the counter at Price Hill Chili's early days is Sam Beltsos (left) and Lazoros Nourtsis, who were often found in the restaurant, as well as Sam's wife, Mimi. *Courtesy of Steve Beltsos.*

Opposite, bottom: This photo of Sam (left) and Lazoros was taken shortly before Lazoros's passing in 2003 at the ripe age of ninety-five. Having lost his father at age eleven, "Pops" was a father figure to Sam. *Courtesy of Steve Beltsos.*

to say hi and have some chili. He heard about Tim Lambrinides opening the Silver Ladle downtown and wishes him well. The brothers came into his restaurant before he opened to give him some friendly advice.

Ç Sam has created a place where politicians like to come. Governors Ted Strickland and John Kasich and Vice President Dick Cheney (in 2004) have stopped by, giving it the nickname the "Republican Chili Parlor." Even Republican presidential candidate Newt Gingrich stopped by in early 2012. Political analyst Gene Beaupre said that candidates appreciate its authenticity and local charm.

d Their elder sports fan clientele have given them another nickname: "Elder Corner." There are five generations coming into the place now. Regulars know that they're going to find a friend there. Sam has created a public meeting place for people to come together on the West Side. It's a place to go to celebrate your victories, commiserate in your defeats and reunite with your family, said Cincinnati councilman John Cranley. PHC offers good food and good conversation.

ç On the menu are such items as the Big Sam Platter, a whopper of a double-decker. They also serve at breakfast a Mega Greek Omelet and another Cincinnati favorite, goetta. It is most crowded on Sunday mornings, being the perfect after-Mass dining spot for hungry churchgoers to discuss the day's sermon and neighborhood gossip.

Lazoros Nourtsis's son, Sam, who opened Sam's Chili on Glenway Avenue in 1967 but has since sold the business, still owns the property. It's more of a walkup than a restaurant and serves chili, burgers, gyros and double-deckers, but it has also earned West Side icon status.

West Side Chili Parlor at 6520 Glenway is the newest newcomer to the scene, having been opened on July 10, 2007, by husband and wife team Glenn O'Dell and Laura Striker, who bought their recipe from silent partner Jim Faust. Jim had been hawking his Cincinnati chili starter spice mix in local grocery stores for years. Aside from the standard Cincinnati-style chili, they have TexMex, vegetarian and spicy vegetarian—all of which can be ordered in a sampler platter. If the standard cheese coney is just too healthy for you, West Side has its "Ripper," a deep-fried version, for your enjoyment. And it has invented a new six-way called the "Glenway," which adds diced dogs on the top. Glenn and Laura call their really spicy coney the "Atomic Coney."

After Hamburger Heaven became Gold Star Chili in 1965 and Adeeb Misleh opened one of the first East Side Skyline franchises in 1962 in Mount Washington, other solo chili parlors opened up in Cincinnati's East Side.

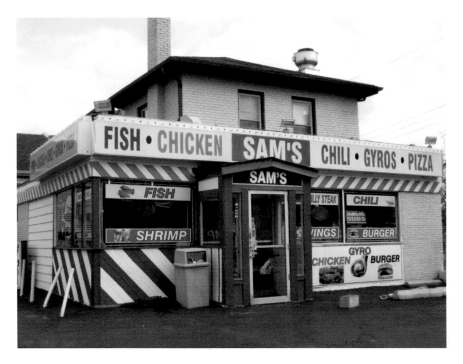

This is Sam's Chili on Glenway Avenue in Price Hill. It was opened in 1967 down the street from the former location of the original Skyline Chili. Founder Sam Nourtsis is the son of Price Hill Chili co-founder Lazoros Nourtsis. *Photo by author.*

In 1953, Stephen J. and Vincent F. Fischesser were operating the Bramble Chili Parlor in Madisonville. By 1965, Art's Chili Parlor at 4906 Whetsel was operating in Madisonville as well to service moviegoers going to and coming from the Grand Theatre at 4009 Whetsel.

East Enders in the early 1950s could see a movie at the Carrell Theatre at 4023 Eastern Avenue and fill their bellies with chili at the Nite Owl Chili Parlor at 4030 Eastern, thanks to owner Sim Bookman.

Cincinnati chili had reached Norwood by 1946. Three parlors—Carl's Chili Kitchen at 4744 Montgomery Road, owned by Herman Davis; the Emperor Chili Parlor at 4193 Montgomery Road, owned by Hyman Peskin; and the Norwood Chili Parlor at 4419 Montgomery Road, owned by Herman and Florence Williams—fed Norwood natives, GM employees and Xavier University students. Another parlor, A. Smiles on Montgomery Road, fed local high school students late night after games and carousing. A longtime Empress Chili in Norwood's Surrey Square Mall gave Norwooders the legacy taste.

Chili parlors had made it to St. Bernard by the 1940s. Pandelis (or "Pete") Vidas (1922–1999) opened the first Chili Time Restaurant in 943 on Vine Street in St. Bernard. Pandelis had emigrated from Variko, Greece, leaving behind parents Christo Konstandionos and Sophia Vidas. He first opened across the street from his current restaurant at 720 Vine Street, and then he opened another store at 7500 Reading Road in Bond Hill. William E. Williams operated the X-L Chili Parlor at 006 Vine Street by 1946.

By the 1960s, Cincinnati chili parlors had been around for nearly four decades. Several chili parlors had moved up Reading Road and Vine Street to the neighborhoods of Reading and Elmwood Place, respectively. Reading had the Chili Bowl at 6110 Vine Street, Cretan's Chili Restaurant at 7039 Vine Street and Vince's Chili Kitchen at 6014 Vine Street. A House of Chili at 509 West Benson Street off Reading fed hungry shoppers in what's now the wedding dress capital of Cincinnati. Bond Hill Chili Parlor at 4890 Reading Road and Art's Chili Kitchen at 8915 Reading Road fed travelers going north out of the city.

PLEASANT RIDGE CHILI

Pleasant Ridge Chili found itself a great location on Montgomery Road in 1964, next to the old Ridge Theatre. Founder Antonius C. "Tony" Sideris, an immigrant from Kastoria, Greece, still worked at the parlor seven days a week, even after he retired in about 2003. After passing away in 2010, Sideris's son, Dan, now runs the parlor. The parlor has been served by three generations of the Sideris family.

Opposite, top: The sign for Pleasant Ridge Chili, founded in 1964 by Antonius "Tony" C. Sideris. *Photo by author.*

Opposite, bottom: The Ridge Theatre next to Pleasant Ridge Chili was typical of a one-screen neighborhood theater. *Courtesy of the Pleasant Ridge Branch of the Public Library of Cincinnati and Hamilton County.*

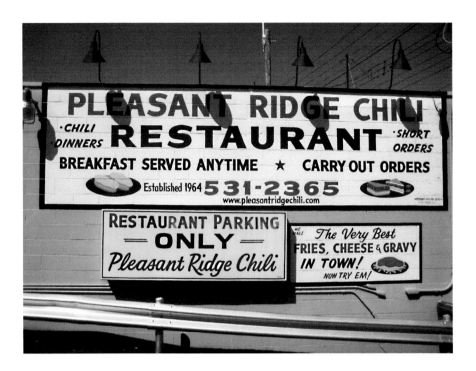

Although the chili is mild, the portions are generous and the wait staff are friendlier than at most Cincinnati chili parlors. Two rows of booths line the walls, and a rectangular counter with swivel stools flanks the kitchen.

With its late-night hours, Pleasant Ridge Chili has a loyal following of police, hospital workers and nighttime revelers. In addition to the normal chili offerings, it's known for its gravy and cheese fries, a sort of Cincinnati poutine designed to curb a lumberjack-like appetite.

BLUE ASH CHILI

Blue Ash Chili on Kenwood Road is the farthest suburban indie chili parlor. Founded in 1968 by Theodor Christopoulos, the parlor was featured on

The counter of Blue Ash Chili during a typical busy lunch service. *Photo by author.*

Diners, Drive-Ins and Dives. In honor of Guy Fieri's trip there, it has the "Guy Way," a fresh bowl of its premium chili with onions and crackers. It also has a six-way, which adds fried jalapeño caps to a standard five-way. Another unique chili concoction at Blue Ash is its Chili Lasagna, made with premium Cincinnati-style chili, sour cream and shredded cheddar cheese.

Christopoulos sold the parlor and his secret recipe in 1997 to couple Jack and Faye Glynn, and his lips are sealed on the recipe or its origin. Although the chili is pretty mild, the menu is extensive, including burgers, stacked double-deckers and another local Greek delicacy, Aglamesis Ice Cream, in floats, shakes and sundaes.

The Glynns have kept pace with the former owner, creating an atmosphere of a 1950s diner with golden age movie stars like Cary Grant, Ava Gardner and Doris Day framed along the walls. Elvis holds prominent status to the owners here, with records tucked along one wall. They also have a challenge called the "No Freakin Way," a chili challenge unique in the city. A customer has sixty minutes to eat two and a half pounds of chili over two and a half pounds of spaghetti, topped with two pounds of shredded cheddar cheese and one pound of fried jalapeño caps. The guest hardy enough to finish the enormous meal in the allotted time gets the meal free and a free T-shirt for bragging rights (or doctor's explanation), as well as a post of your photo to its Facebook Hall of Fame. If you don't finish, your photo goes instead on the Wall of Shame, and you are slapped with a bill of $39.99!

The history of Cincinnati chili parlors is spiced with the story of many solo chili parlors, the majority of which were owned by Macedonian and Greek immigrants. Although many have been forgotten and many are no longer around, some survive as sacred institutions in Cincinnati. Those that didn't make it paved the way for Gold Star and Skyline to open chains in neighborhoods already familiar with the distinct taste of Cincinnati-style chili.

SELECTED BIBLIOGRAPHY

Books

Horstmann, Barry M. "100 Who Made a Difference: Greater Cincinnatians Who Made a Mark on the 20th Century." *Cincinnati Post Publishing*, 1999.

Lambrinides, Billy. *Visions of Plum Street: An Often True and Inappropriate Comedy about Christmas and Skyline Chili.* Hollywood, CA: CreateSpace Publishing, 2011.

Shortridge, Barbara Gimla, and James R. Shortridge. *The Taste of American Place: A Reader on Regional and Ethnic Foods.* Lanham, MD: Rowman & Littlefield Publsihers, 1998.

Singer, Allen J. *Stepping Out in Cincinnati: Queen City Entertainment, 1900–1960.* Charleston, SC: Arcadia Publishing, 2005.

Weber, Robert D. *The Balcony Is Closed: A History of Northern Kentucky's Long-Forgotten Neighborhood Movie Theatres.* Covington: Kenton County Historical Society, 2007.

Interviews/Correspondence

Bazoff, Phillip. Personal interview, January 5, 2013.

Beltsos, Sam, and Steve Beltsos. Personal interview, December 19, 2012.

Bowman, Art. Telephone interview, November 2012.

Christofield, Dorothy. Telephone interview, November 21, 2012.

Daoud, Samir. Personal interview, November 2 and December 6, 2012.

Howard, Charlie. Telephone interview, October 2012.

Johnson, Johnny, and Maria Johnson Papakirk. Personal interview, November 29, 2012.

Kiradjieff, Ed. Kiradjieff genealogy, 2012

—————. Telephone interview, January 2013.

Kiradjieff, Joe. Personal interview, November 17, 2012.

Kiradjieff, John. Personal interview, December 10, 2012.

Lambrinides, Bill. E-mail, January 16 and 24, 2013.

Manoff, Thomas, Jr. Telephone interview, November 2012.

Manoff, Todd. Manoff genealogy, 2012.

—————. Telephone interview, November 22, 2012.

Newman, Steve. Personal interview, November 17, 2012.

Perdikakis, Gus. Personal interview, January 3, 2013.

Sarakatsannis, Spiro. Personal interview, November 12, 2012.

Stavropoulos, George. Personal interview, December 2012.

Miscellaneous City Sources

Cincinnati city directories, 1919–84. Public Library of Cincinnati and Hamilton County, Cincinnati, Ohio.

Covington city directories, 1929–76. Kenton County Public Library, Covington, Kentucky.

Spring Grove Cemetery burial records. Spring Grove Cemetery Archives, Cincinnati, Ohio.

Western Hills High School yearbooks, 1946–51. Price Hill Historical Society, Cincinnati, Ohio.

Periodicals

Berler, Ron. "The Red Hot Guide to Cincinnati Chili." *Cincinnati Magazine* 12, no. 1 (October 1978): 62.

Covret, Donna. "Mmm Chili!" *Cincinnati Magazine* 42, no. 10 (July 2009): 56–67.

Food Network Magazine. "Hot Spots: Warm Up with Three Unique Chilis." January 2013, 150.

Najar, LuAyy. "Up to My Ears in Chili." *Jordan Business*, March 2007.

INDEX

ABOUT THE AUTHOR

Dann Woellert is a self-admitted history geek and foodie, tracing his interest in history back to a winning grade school history fair project titled, "Did You Know There Was Once Cocaine in Coca-Cola?" This is his third book, having published *Cincinnati's Northside Neighborhood* (Arcadia Press, 2009) and *Cincinnati Turner Societies* (The History Press, 2012). He is a member of the Cincinnati Preservation Association and for several years was an Architreks Tour Guide, having created its Historic Tour of Northside/Cumminsville. He is active in several regional historical societies, including the Campbell County Kentucky Historical Society. Dann has taken culinary courses in Bologna, Italy, as well as regionally and has eaten many strange foods across the

The author in front of the Parthenon in Athens, Greece, in search of archaeological evidence of the origin of Cincinnati-style chili. No carved friezes or statues of goddesses holding cheese coneys were found.

globe on business trips. Dann enjoys culinary trips to wine and bourbon country and is a home craft brewer. He lives within two miles of a Skyline and Gold Star Chili Parlor.

Visit us at
www.historypress.net
..
This title is also available as an e-book